IMAGES
of America

CLOVER

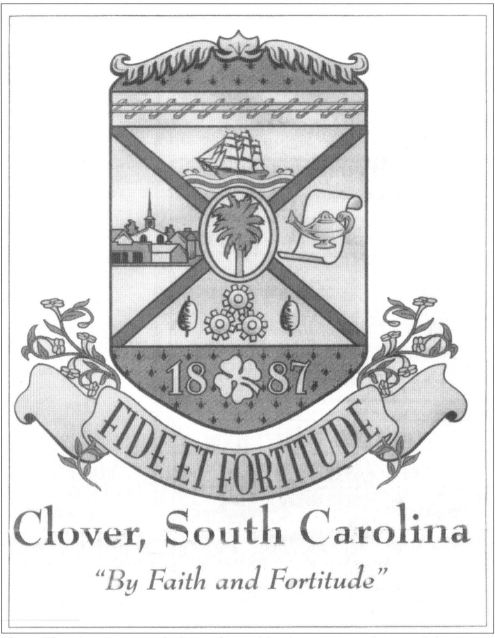

Clover, South Carolina

"By Faith and Fortitude"

This is Clover's town crest, which was designed by then-executive director of the Greater Clover Chamber of Commerce, Linda Myers. Two green sections at the top of the crest represent the coat of arms of the Smith family, one of Clover's founding families. The ship represents immigrants, and the two swans represent Clover's ties to Larne, Northern Ireland, Clover's twin city. Also included are ties to agriculture, church, neighborhood, and the textile industry. (Photo courtesy of Margaret and Linden Smith.)

IMAGES
of America

CLOVER

Karan M. Robinson and Christina Stiles

ARCADIA

Published by Arcadia Publishing
an imprint of Tempus Publishing Inc.
Charleston SC, Chicago, Portsmouth NH, San Francisco

Printed in Great Britain

Library of Congress Catalog Card Number: 2004100456

For all general information contact Arcadia Publishing at:
Telephone 843-853-2070
Fax 843-853-0044
E-mail sales@arcadiapublishing.com
For customer service and orders:
Toll-Free 1-888-313-2665

Visit us on the internet at http://www.arcadiapublishing.com

This book is dedicated to Margaret and Linden Smith, Ed Stewart, and Margie Smart, gracious souls who keep Clover's history alive.

CONTENTS

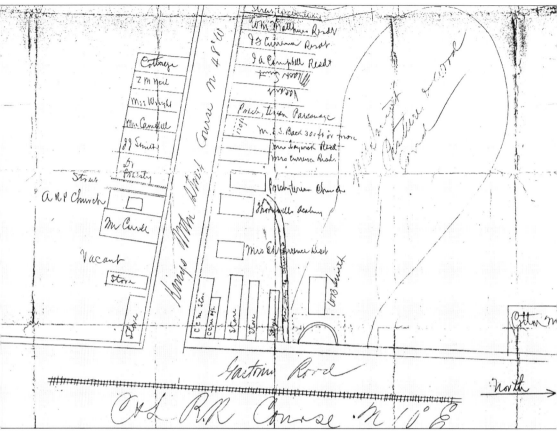

This is a hand-drawn map of Clover in 1895. (Photo courtesy of Margaret and Linden Smith.)

ACKNOWLEDGMENTS

This book would not exist if not for the generosity and graciousness of individuals and organizations who kindly shared their photographs and remembrances with us. We would like to thank Margie Smart and James and Peggy Byrd, who got us started; Margaret and Linden Smith for their wealth of information and hospitality; Ed Stewart for his humor and knowledge; South Carolina state representative Herb Kirsh (D-Clover), for his smile that never faded; Sadie Moss of Green Pond United Methodist Church for her patience; and Pastor Alan A. Morrow of Bethany A.R.P. Church for his kindness.

We also appreciate the enthusiasm of Brent Clinton; the kind-hearted Jonathan Thomas and Lib Thomas; the persevering Ann Harvey on a visit to the Larne Building; Dickie and Charlotte Jackson for taking time out of their workdays; Jim Wylie for his knowledge; Sara L. Jackson for her graciousness; the delightful Marge Jackson Woods; the friendly Sarah B. Jackson; Adelle Edmunds, who gave us gems; and the York County Culture and Heritage Commission's Heather South, who worked late more than once to assist us. Thank you also to Charles Ford, Jack Westmoreland, and the 1998 Feis Chlobhair Program. Last, but not least, we thank Columbus "Shorty" and Clara Faye Stiles, Claude and Frances Robinson, and Sherman and Joanne Moses for being there.

Special thanks are due to Mark, Lindsay, and Megan, who didn't give up. Special thanks also go to Tracy, Faye, Shorty, and Wheezie for love and support.

INTRODUCTION

History is defined as a chronological chain of significant events that help establish and explain our past, and as the days blend into years, and then turn to centuries, that past is woven tightly into the fabric of the present. Yet the present is ever changing, with history continually being made, usually in a subtle manner; indeed, the Clover of today will not look the same as the Clover of tomorrow.

Clover, a relatively young town, was founded in the mid-1870s, when it became a watering station for the steam engines on the Chester and Lenoir Narrow-Gauge Railroad. The water tank for the steam engines was a focal point around which Clover developed. The 15-foot-high water tank stood on 6 legs, was 10 to 12 feet in diameter, and held 5,000 gallons of water.

Legend has it that Clover got its name from a patch of clover that flourished under the water tank, although some researchers believe the town was given its colorful name to entice newcomers to the area. Regardless of how Clover got its name, the town, which was officially incorporated in 1887, thrived. In 1882, Clover's population numbered 70, and the town was home to several stores, a blacksmith shop, a post office, and a church. By 1890, the population had climbed to 287. Capt. William Beatty Smith, a Clover businessman, raised $30,000 to build the first textile mill in town, and by 1924, Clover had three textile mills. Smith's three sons, Myles Linden Smith, James Meek Smith, and William Patterson Smith, were also instrumental in developing business in Clover.

Other folks, as well, were living in the Clover area long before the town was established. There is a large Scotch-Irish population in Clover, as well as throughout the southeast, and some residents trace their ancestry back to David and Mary Morrison Jackson, who were among the first settlers in the area. According to Jack Westmoreland's *And Clover Began To Grow*, David Jackson was born in Ireland in 1745, and after King George III bestowed a 903-acre land grant upon him in 1774, David sailed to America with his wife Mary. The couple went on to have 10 sons, the first of whom was born on the voyage from Ireland. David Jackson fought as a Patriot at the Battle of Kings Mountain during the Revolutionary War, and, despite being wounded there, returned home. In the 1790s, he purchased 1,700 acres in the Clover area.

In the 1820s, a small community called New Centre sprang up just to the south of what is now Clover, and a post office was established in 1851. The post office operated throughout the Civil War as a Confederate States post office, but by 1874, it had closed.

One of the first to volunteer for service during the Civil War was Samuel L. Campbell, who was born in the Bethel community of Clover on August 26, 1829. Campbell was wounded

during battle in Virginia and lost his eyesight as a result. When he returned to Clover, "Blind Sam," as he was called, went to work pumping water for the tank in Clover. Sam, who was well liked, spent hours carving and whittling items from wood, many of which he gave away.

In 1876, W.B. Allison made Clover's first survey for about 20 lots. The only dwelling in town that year belonged to Maj. J. Nelson McCall, a well-known brick mason, but soon others built homes close to the railroad, including Capt. William Beatty Smith. Captain Smith owned a store and served as train depot agent.

In the early years, Clover had several good doctors to care for the growing town. Dr. A.P. Campbell, Clover's first doctor, was born in the Bethel community in 1827. Dr. Campbell served the Clover area for over 40 years until his death in 1891. Dr. Campbell also helped bring Dr. E.W. Pressly to town. Dr. Pressly, who attended Maryland Medical College and received the Prize Man Award for his high grade point average, arrived in Clover in 1887. Dr. James W. Campbell and Dr. Marshall B. Neil were also early doctors in Clover.

By 1910, a school had been built on Pressly Street, and the first rural police force in York County was formed. It was made up of three men, John Hayes and Charlie Moss of Rock Hill and John Andy Jackson of Clover, who was elected Clover's police chief in 1916. Mr. Jackson held that position for over 22 years. Stellie Jackson, who was born in York County in 1892, was Clover's first African-American policeman.

As time marched on, Clover, like the rest of the nation, dealt with World War I, the Depression, and World War II. For many years on Armistice Day, which marked the end of World War I, Clover held a parade in celebration. When Roosevelt was elected president in 1932, some men of the town held an impromptu "Burial of Hoover" or "The Burial of Wilkie" parade, referring to Roosevelt's opponent, Wilbur Wilkie.

More recent events in Clover have included making improvements to the African-American Roosevelt neighborhood and establishing a sister city relationship with Larne, Northern Ireland, to celebrate the Scotch-Irish heritage of many area people. But the most important thing in Clover is the people who enjoy small town life and a strong sense of community.

It is our hope that each reader will find something of interest in this book and will be inspired to learn more about the history of Clover and the surrounding areas. Perhaps you will pick up a camera or record the thoughts of your everyday lives in a journal, weaving the present into the future.

One
FAMILY AND FOLKS

Myles Smith was married to Rebeca Arabella Patrick, sister of John A. Patrick.

New Centre S.C. Free from Myles Smith PM

Sept 24, 1855 (to) Capt John A. Patrick

 Dirt Town Georgia

Dear Brother,

Time rolls on without a moments stay and has about a period when I conclude and deem it my duty to write you a few lines, we are all well at present, and the neighbors generally are also well, your brothers and sisters and family are all well, but Pauline[1] is sorely distressed, her third daughter is likely to be a cripple like the other two, it is distressing to see them, but Oh Allison, the painful tidings I have to state to you must come next, Sylvester[2] has bid us a final farewell, you must excuse me if I do not write sufficient about him for I am so overwhelmed I cannot think as I should. He look unwell on Friday night 7th inst and on wednesday eve about dark he breathed his last. It was the sorest trial I ever had; I took home the next day and friday morning committed his body to its narrow house, his disease was inflamation of bowels, he has never been sound since he had the same kind of attack before he went to Georgia. We have some consolation in his death, if he had died in Texas or been overwhelmed in the Gulph of Mexico it would have been a thousand times worse. We bless the Lord for sending him home to us to die surrounded by his father and mother and brothers and friends; and friends he had. I have heard some of the vilagers say he had not an enemy in York. All I have met with lament his death. But oh doctors and friends cannot avail, his time was come and he had to go, let us prepare to follow him. I send you a newspaper containing an account of his death also a piece of poetry some of the vilagers composed on his death but I know not who it was; H. John is still with Lowery & Avery, Robert and Beatly are going to school. I would here state that Frank Jacksons Mary is in bad health, something like consumption and from what I hear of her, her days will be short. Old Mrs Peters is yet alive, she and mother went to the grave when I took Sylvester, old John Fitchett has been poorly this summer at times I hear no talk of any of them marrying, Jonathon is capt of your old company, Lee Parish first Lieut, Robert 2nd Lieut, & Hugh Hemphill Ensign. It would do you good to see the company now. It is a complete uniform company and last saturday they received muskets. Bill Pursley and myself have joined. We have a bountiful harvest of wheat, corn & oats, and cotton is very good and is selling at York about 9

Appendix P-6

Pictured here is a copy of a letter postmaster Myles Smith wrote to his brother-in-law John A. Patrick of Dirt Town, Georgia. The letter was sent from New Centre, a small community that existed before Clover was established. (Letter courtesy of York County Culture and Heritage Commission.)

9

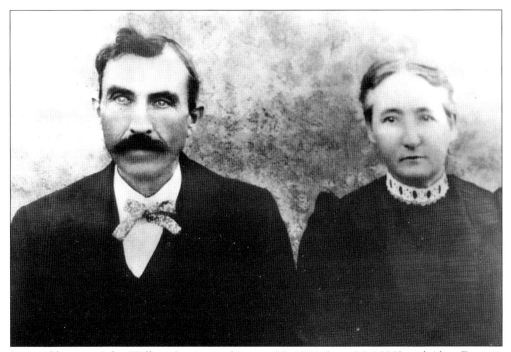

Pictured here are John William Lawrence (August 27, 1844–June 26, 1920) and Alice Eugenia Jackson Lawrence (1846–1912), parents of Alice Eugenia Lawrence Edmunds. Alice Eugenia Jackson Lawrence was the daughter of Col. Andrew Jackson and Mary Campbell Jackson. John William Lawrence's grandfather, Joseph Lawrence, lived on his land grant plantation on Lawrence Road in Clover. Joseph Lawrence was born in Virginia in 1762 and is buried at the Bethel Churchyard cemetery near Clover. (Photo courtesy of Adelle Edmunds.)

Myles Linden Smith is shown at age nine. Photographer J.R. Schorb of Yorkville, South Carolina, took the photograph in 1878. (Photo courtesy of Margaret and Linden Smith.)

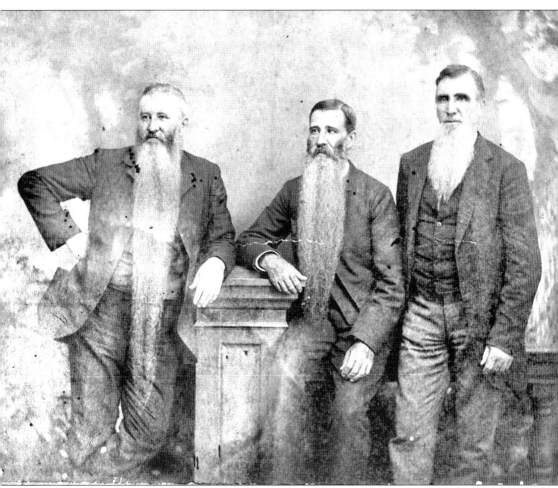

Unreconstructed Confederate brothers Capt. William Beatty Smith, John Josiah Smith, and Robert Patrick Smith are shown *c.* 1880. Captain Beatty and John Josiah were both wounded in the Civil War. After the war, Robert Patrick Smith moved to Texas. (Photo courtesy of Margaret and Linden Smith.)

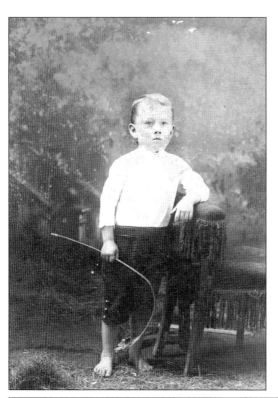

This is a photograph of Fred Hope Jackson as a child in the 1880s. Fred Jackson was born June 16, 1881, and died in 1949 at the age of 68. (Photo courtesy of Margaret Jackson Woods.)

John Leslie Wright and Myles Linden Smith go for a spin on their "wheels." By 1885, bicycles had advanced to two equal-sized wheels, making them much easier to ride. (Photo courtesy of Margaret and Linden Smith.)

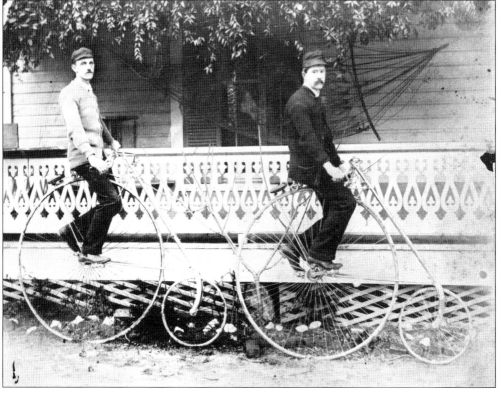

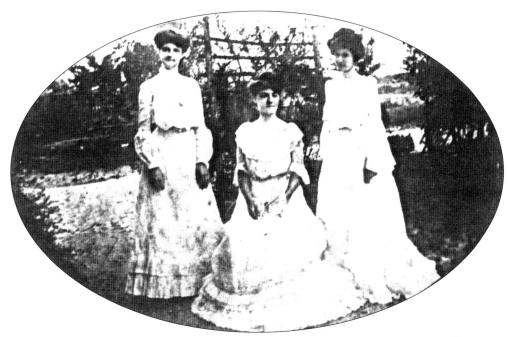

Annie Laurie McCall, Sarah Eleanor McCall, and Mary Leone McCall pose for this 1890s photograph. (Photo courtesy of Margaret and Linden Smith.)

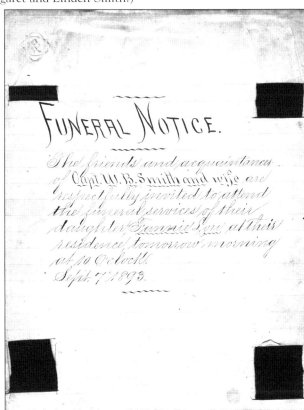

FUNERAL NOTICE.

The friends and acquaintances of Capt. W. B. Smith and wife are respectfully invited to attend the funeral services of their daughter, Fannie Lou, at their residence, tomorrow morning at 10 o'clock.

Sept. 7, 1893.

Pictured here is a September 7, 1893 funeral notice for Capt. Beatty and Elizabeth Smith's daughter, Fannie Lou, who died of scarlet fever. (Photo courtesy of Margaret and Linden Smith.)

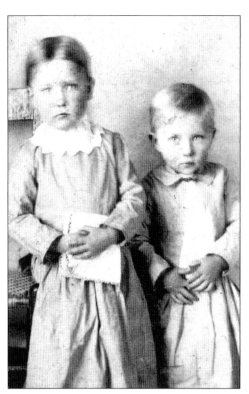

Pictured here are John Andy Jackson and his sister, Mary Eliza Jackson, c. 1890. John Andy Jackson was Clover's police chief for 20 years. (Photo courtesy of Sara L. Jackson.)

Samuel Thomas Dunham McCall and his wife, Margaret Barber McCall, take their family on a trip to Blowing Rock. The family traveled in oxen-pulled tandem wagons. (Photo courtesy of Margaret and Linden Smith.)

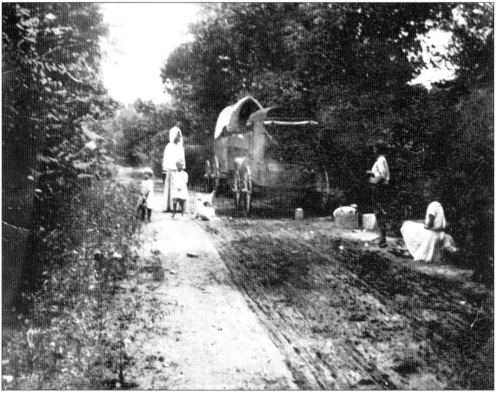

Fred Jackson was born in the Bethel community in 1881 and attended Bethel public schools and Kings Mountain Academy in York. This photograph was taken at Kings Mountain Academy. (Photo courtesy of Margaret Jackson Woods.)

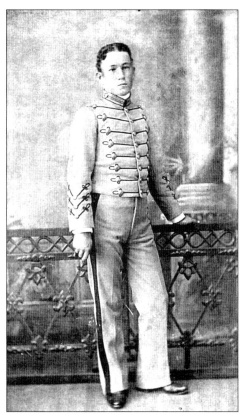

This photograph of the 201 Kings Mountain Street home of Dr. and Mrs. Ebenezer Wideman Pressly was taken on November 28, 1894. Dr. Pressly, one of the town's most beloved citizens, served the Clover community for 44 years. Standing left to right are Harriet Louisa Pressly, an unidentified maid, John Josiah Smith, Addie McMurry, Dr. Pressly, and Mary Amelia Jane McFadden Smith. The house still exists, although a second story has been added. (Photo courtesy of Margaret and Linden Smith.)

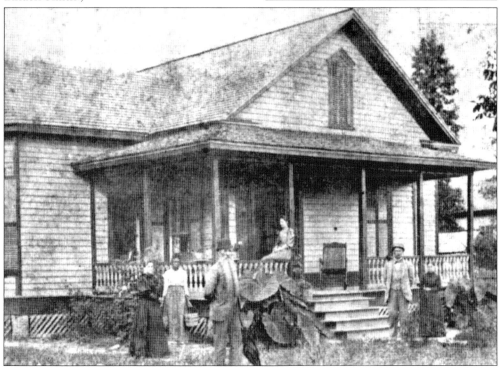

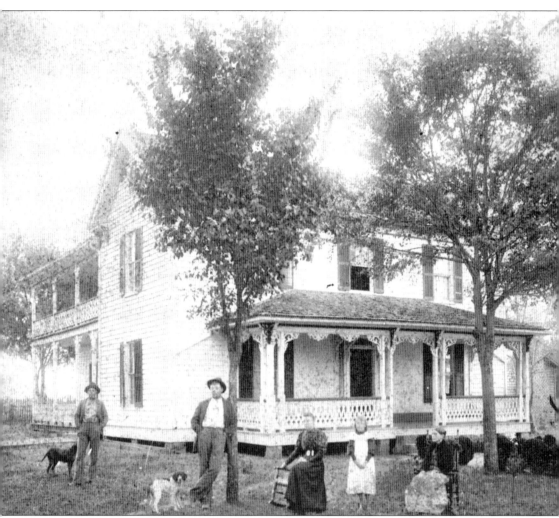

The Campbell siblings enjoy the outdoors at their home in 1895. From left to right are Lee Campbell, Les Campbell, Sally Campbell, Hattie Campbell, and Betty Campbell. Today the dwelling is known as the Clinton house and is occupied by Brent and Laura Clinton. Lee Campbell passed the house to his nephew, Howard "Boot" Clinton, Brent's grandfather. (Photo courtesy of Brent Clinton.)

This portrait is of Maj. James Nelson McCall, a well-known brick mason. McCall, who was born in May 1822, erected the first dwelling in the newly formed town of Clover in 1876. Major McCall died August 10, 1908. (Photo courtesy of Margaret and Linden Smith.)

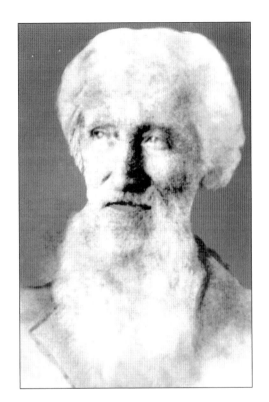

This photograph was taken by J.R. Schorb in the late 1800s. Bethel belle Lillie Armstrong is pictured. (Photo courtesy of Margaret Woods Jackson.)

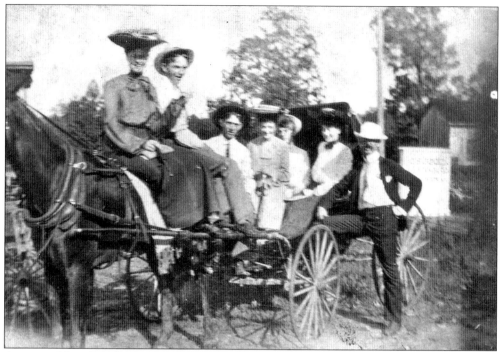

A group of friends gather at Roy Jackson's farm in this undated photograph. (Photo courtesy of Margaret Jackson Woods.)

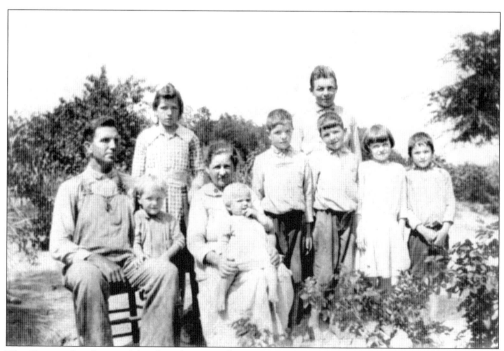

The Biggers family posed for this photograph, c. 1915. The family is as follows, from left to right: (front row) Robert Andy Biggers, Bob, Etta Lula Boyd Biggers, holding Bertie; (middle row) Lola, Vess, Jesse, Myrtle, Craig; (back row) Roy. (Photo courtesy of Margie Smart.)

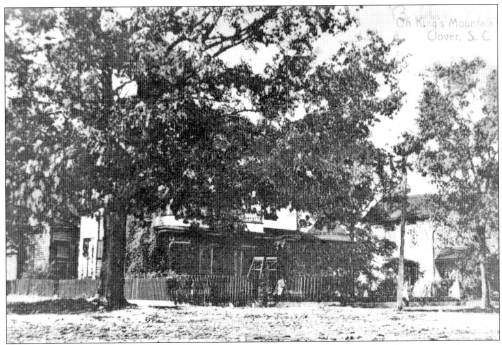

The residents of this house on Kings Mountain Street most likely took refuge under the shade of this tree during hot, humid Southern summers. (Photo courtesy of Ed Stewart.)

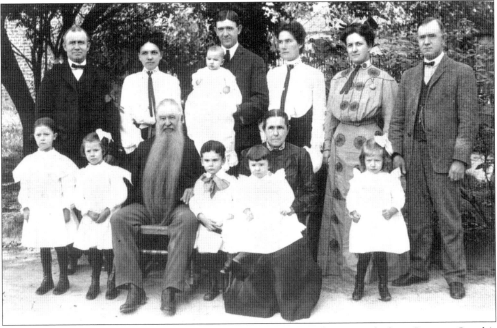

The growing Smith family, c. 1904, posed for this portrait five years before Captain Smith's death. Pictured from left to right are (front row) Louise; Christine; Capt. William Beatty Smith; Herbert; Mrs. Elizabeth Smith, holding Claudia, Meach's daughter; and Frances; (back row) Meach; Jenny; Willie, holding his son, Justin; Lena; Daisy; and M. Linden. (Photo courtesy of Margaret and Linden Smith.)

19

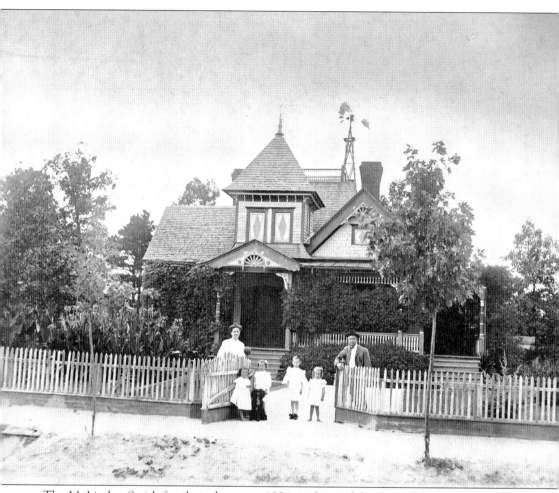

The M. Linden Smith family is shown, c. 1904, in front of the Smith home, built in 1896, at 206 Kings Mountain Street. Standing from left to right are Daisy, Ethel Adams, Christine, Louise, Frances, and M. Linden. The house was destroyed by fire in 1908. (Photo courtesy of Margaret and Linden Smith.)

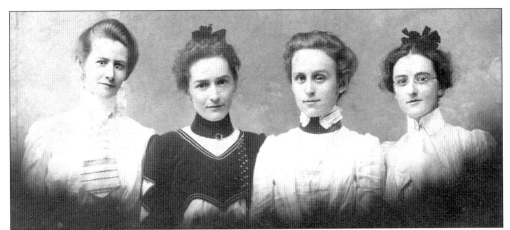

These well-to-do ladies were from the Bethel community near Clover and posed for this photograph around the turn of the 20th century. Pictured from left to right are Mary Hope Adams, Francis Emma Ford, Jane Jackson, and Lula Hunter Ford. (Photo courtesy of Margaret Jackson Woods.)

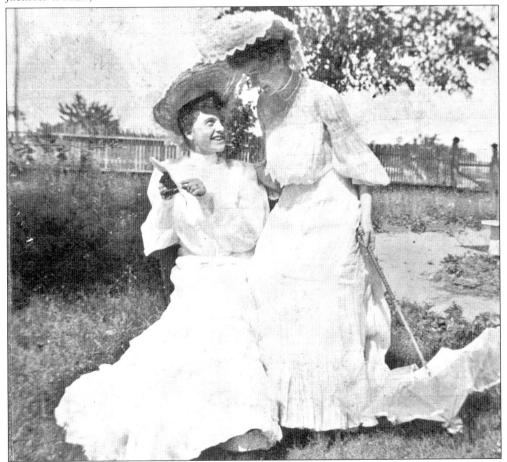

Emma Ford and Bess Little appear amused in this undated photograph. Notice the parasol, which offered a shield from the sun. (Photo courtesy of Margaret Jackson Woods.)

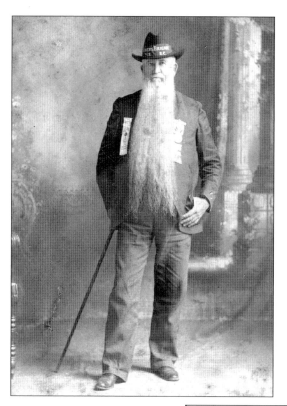

Capt. William Beatty Smith, pictured here in 1905 wearing his Confederate reunion badges, joined the Confederate Army as third sergeant in the Jasper Light Infantry. He held the rank of captain of the Company G Palmetto Sharpshooters when his regiment surrendered at Appomattox. (Photo courtesy of Margaret and Linden Smith.)

These are Captain Smith's Confederate reunion badges, which show he was a member of Micah Jenkins's Confederate camp during the Civil War. He was one of the first men in York County to volunteer to fight for the Confederacy. (Photo courtesy of Margaret and Linden Smith.)

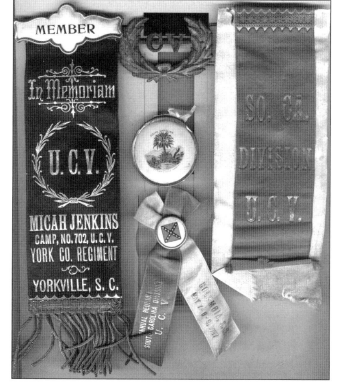

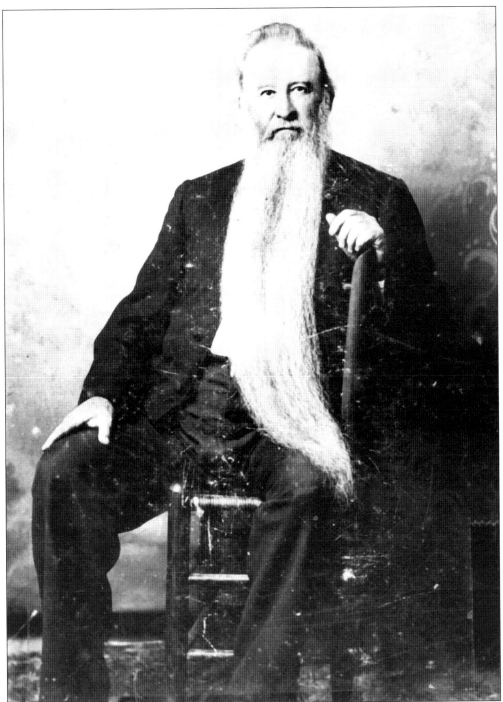

Capt. William Beatty Smith swore not to cut his beard until the Confederacy proved victorious over the Union. After the South's defeat, he continued to let it grow. He died in 1909 with the beard still uncut. The beard, which his wife plaited every Monday morning, was said to be 53 inches long and was held to be the longest beard in York County. (Photo courtesy of Margaret and Linden Smith.)

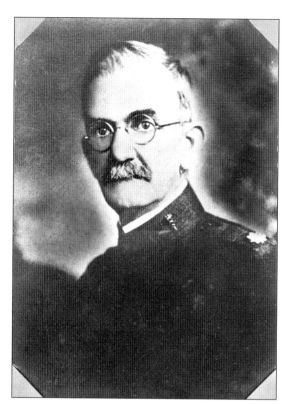

Before coming to Clover in 1887, Dr. E.W. Pressly attended Erskine College and the University of Maryland School of Medicine in Baltimore. Dr. Pressly was born in Anderson County, South Carolina, on November 20, 1863. He died July 24, 1931. (Photo courtesy of Sara L. Jackson.)

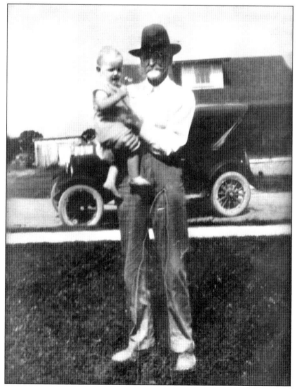

This is a photograph of Capt. William Isaac Brison (October 23, 1857–October 24, 1927), an early Clover contractor, holding his granddaughter, Adelaide Brison. Brison and his wife Mary Patterson Jackson Brison had six children. (Photo courtesy of Margaret and Linden Smith.)

This is a tintype picture of quail-hunting Dr. Isaac Campbell, a physician who came to Clover in 1905. He was mayor of Clover for eight years, served in the South Carolina House of Representatives from 1925 to 1928, and was a state senator from 1928 to 1931. Dr. Campbell also was vice president of First National Bank. (Photo courtesy of Margaret and Linden Smith.)

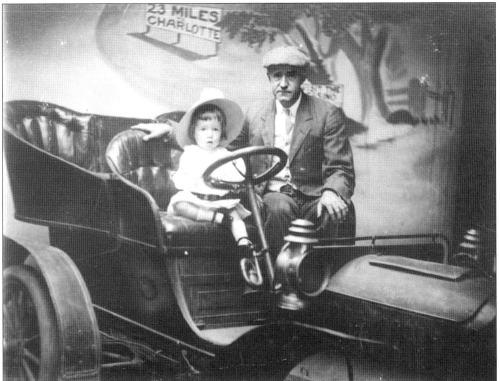

Myles Linden Smith is shown, c. 1909, with his son Edward, who was around two years old. (Photo courtesy of Margaret and Linden Smith.)

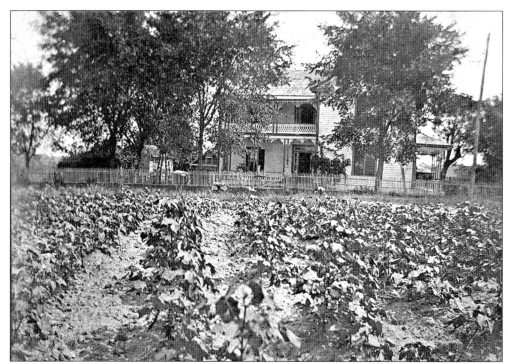

Cotton grows in front of the home of Roy Jackson in this undated photograph. Roy Jackson was Fred Jackson's brother. (Photo courtesy of Margaret Jackson Woods.)

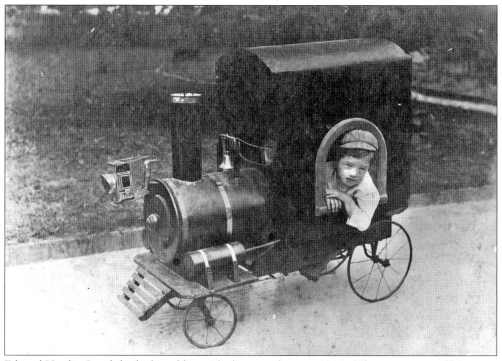

Edward Hardin Smith had a lot of fun with this prized toy, *c.* 1911. (Photo courtesy of Margaret and Linden Smith.)

Myles Linden Smith (January 31, 1869–June 14, 1931) was secretary and treasurer of Clover Cotton Manufacturing Company (often referred to as the Clover Spinning Mill) in 1890, and he helped bring Hawthorn Mill to Clover in 1916. In 1923 he was instrumental in bringing the Hampshire Mill to Clover. He was married to Daisy Hardin Smith. They had four children. (Photo courtesy of Margaret and Linden Smith.)

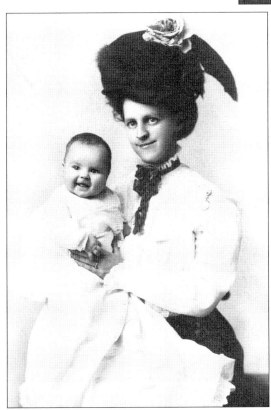

Mrs. I.J. Campbell with her first child, Lavinia, is pictured c. 1912. (Photo courtesy of Margaret and Linden Smith.)

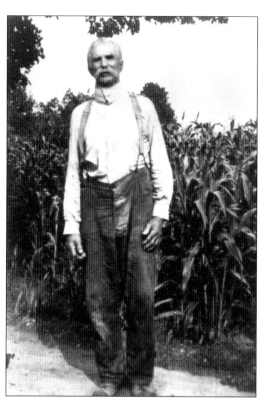

James Daniel Biggers stands in front of his cornfield in this undated photo. (Photo courtesy of Margie Smart.)

Clover was, and still is, made up of many rural homes. (Photo courtesy of Margie Smart.)

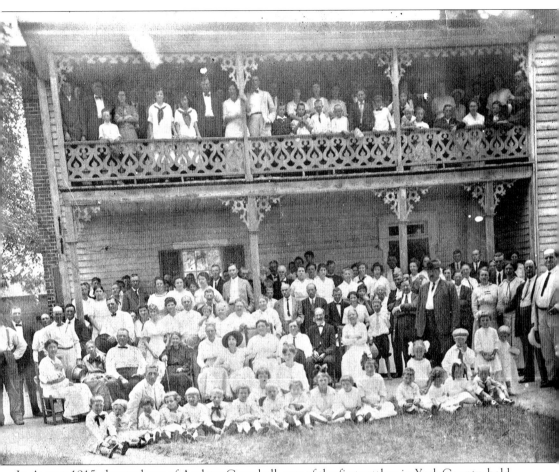

In August 1915, descendents of Andrew Campbell, one of the first settlers in York County, held a reunion at the home of R. Leslie Campbell and A. Lee Campbell. The house, built in the early 1880s, was the second house built on the Campbell property. According to a *Yorkville Enquirer* article, Dr. E.W. Pressly spoke at the reunion, praising the Campbell family for their valiant civil and religious liberty efforts. Dinner was served on a 60-foot-long table loaded with ham, chicken, roast beef, mutton, jellies, and pies. When Howard "Boot" Clinton returned home after serving in World War II, he inherited the house from his uncle Lee Campbell. (Photo courtesy of Brent Clinton.)

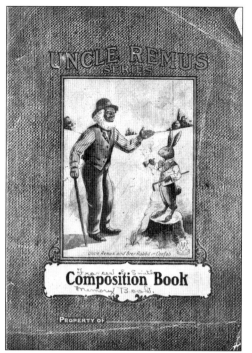
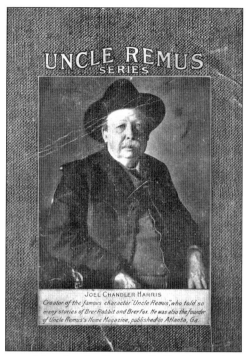

Shown are the covers of the Uncle Remus composition books Frances E. Smith used as scrapbooks during her teenage years. Frances, daughter of Myles Linden and Daisy Hardin Smith, died at the age of 17 in 1918 from the influenza pandemic. Due to the pandemic, there were five or six funerals on the day of Frances Smith's. (Photo courtesy of Margaret and Linden Smith.)

This is a page from Frances E. Smith's scrapbook displaying the Please-U Theatre's playbill for *The Little American*, shown in October 1917. Frances's handwritten notes about her experience there are at the bottom of the page. Established by James Meek Smith, the Please-U Theatre was Clover's first movie theatre; it later became the Carolina Theatre. (Photo courtesy of Margaret and Linden Smith.)

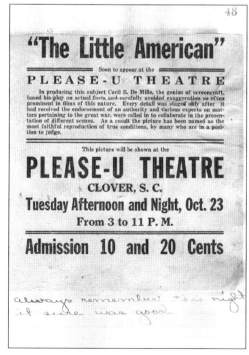

Edward Smith and Herbert Wright Jr. stand in front of the original Clover Presbyterian Church c. 1918. (Photo courtesy of Margaret and Linden Smith.)

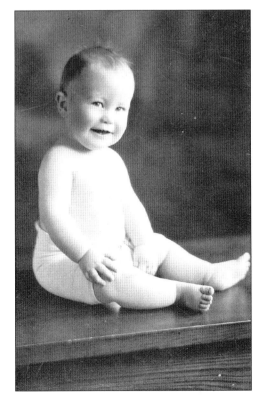

It must not have been hard to get Howard "Boot" Clinton to smile for the camera, c. 1900. The Clinton family was related to Andrew Campbell, one of the first settlers in the Clover area. (Photo courtesy of Brent Clinton.)

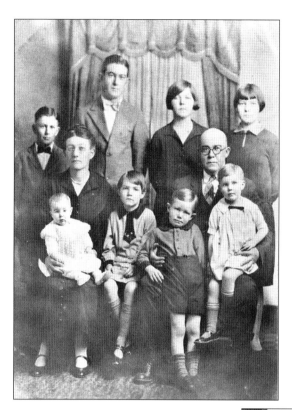

The Clinton family posed for this photograph *c.* 1920. Pictured from left to right are (front row) Hattie Clinton, holding Harriet; Katie; Howard "Boot"; Robert Oscar Clinton, holding Hazel; (back row) R.O.; Samuel; Mary; and Grace. (Photo courtesy of Brent Clinton.)

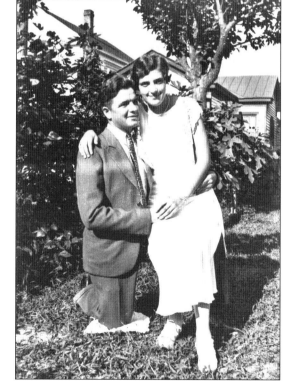

Jesse and Carrie Biggers were all smiles for this photograph. Notice that the gentleman kneeled on a handkerchief to keep from getting his trousers dirty. (Photo courtesy of Margie Smart.)

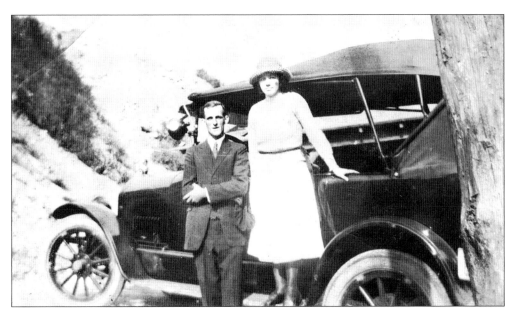

Rube and Lola Smart are dressed and ready for a ride in this undated photograph. (Photo courtesy of Margie Smart.)

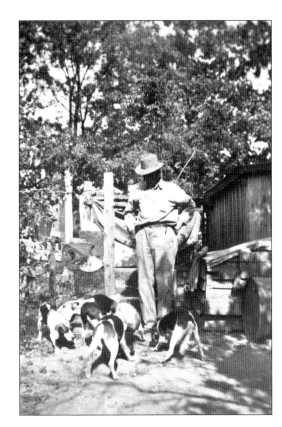

Robert Andy Biggers and his beagles are shown outside his home in this undated photograph. (Photo courtesy of Margie Smart.)

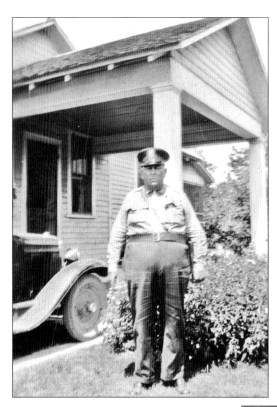

Police Chief John Andy Jackson, in uniform, stands outside his home. Jackson was one of the first rural policemen for York County and served as Clover's police chief for 20 years. He and his wife Mattie Belle Love Jackson had three children. Mr. Jackson was born May 12, 1889, and died September 11, 1938. (Photo courtesy of Sara L. Jackson.)

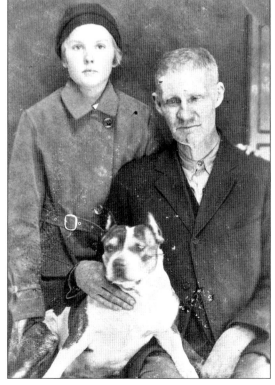

Sara L. Jackson poses for a photograph with Dave Youngblood and Baby Dog c. 1930. Mr. Youngblood oversaw the water department for the town of Clover for many years. (Photo courtesy of Sara L. Jackson.)

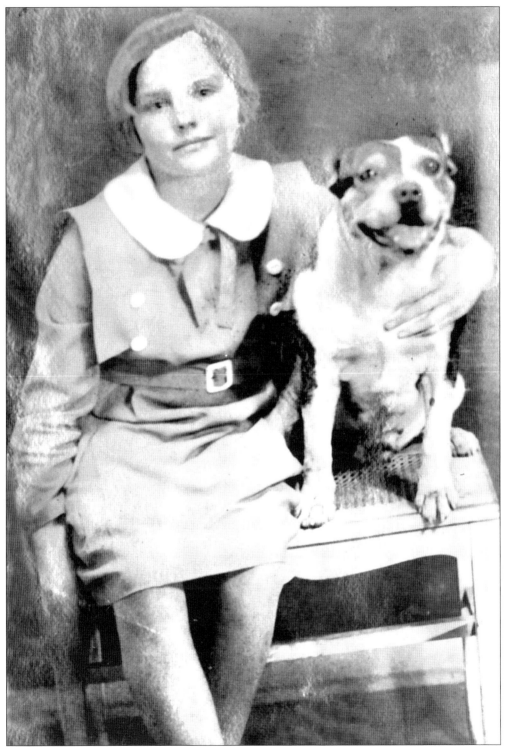

Sara L. Jackson and Baby Dog are pictured *c.* 1930. (Photo courtesy of Sara L. Jackson.)

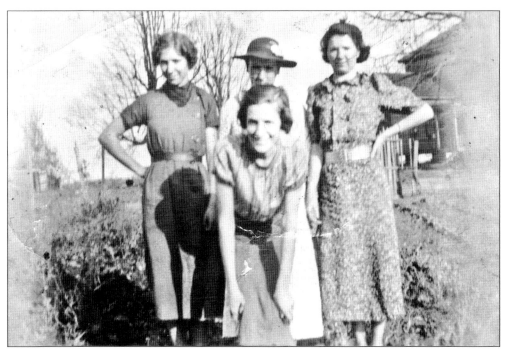

The Teeter family posed for this picture *c.* 1930. (Photo courtesy of Sherman and Joanne Moses.)

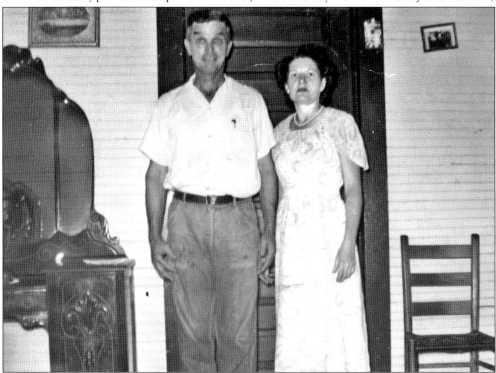

Moffat and Louise Moses stand in the living room of their Linden Street home *c.* 1930. Moffat Moses worked in textiles and Louise was a homemaker. The couple had seven children. (Photo courtesy of Sherman and Joanne Moses.)

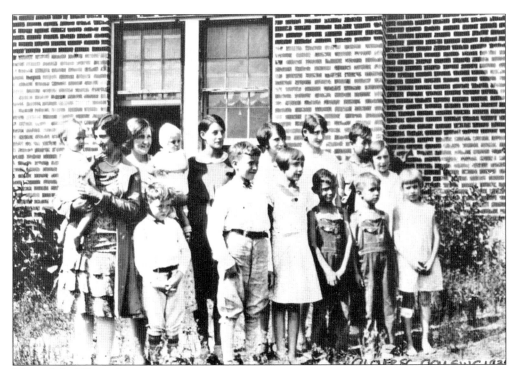

Most of the Edmunds cousins got together for this 1930s photograph. They are, from left to right, (front row) Jack Lawrence; Junior Lawrence; Mary Lawrence; Jennings "Mooks" Edmunds; Robert "Fatty" Edmunds; Sara Lawrence; (back row) Kate McCarter, holding John Wesley Edmunds; Alice McCarter, holding Dorothy Lawrence; Johnsie McCarter; Francis McCarter; Mary McCarter; and C.P. Lawrence, Jr. (Photo courtesy of Adelle Edmunds.)

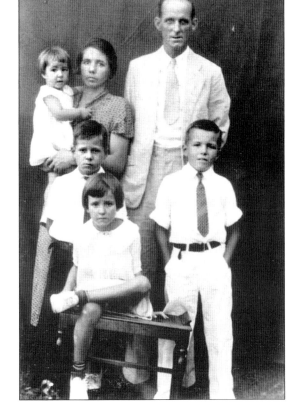

The Smart family posed for this formal photograph c. 1930. They are, from left to right, (front row) Betty Lou, (middle row) Sidney and Lindsay, (back row) Lola, holding Margie, and James R. Smart. (Photo courtesy of Margie Smart.)

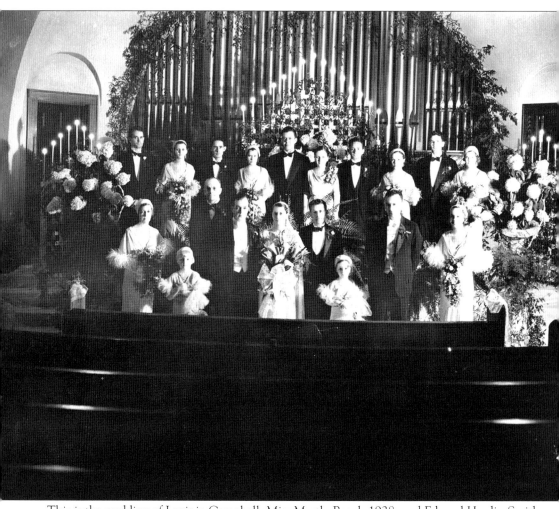

This is the wedding of Lavinia Campbell, Miss Myrtle Beach 1928, and Edward Hardin Smith on August 18, 1932, at the First Presbyterian Church in Clover. In 1989, *Southern Bride* included the photograph in the "In the Grand Tradition" section of its magazine. (Photo courtesy of Margaret and Linden Smith.)

This photo was taken beside the home of Mr. and Mrs. Robert Adams Jackson on Bethel Street in the mid-1920s. Pictured are, from left to right, Lavinia Campbell Smith, Martha Jackson Curry, Emily Sifford Spears, Grace Campbell Smith, and Maude Jackson Curry. (Photo courtesy of Margaret and Linden Smith.)

This is a portrait of Lillie Brison Campbell, c. 1940. Mrs. Campbell was awarded a citation for meritorious service for her outstanding contribution to the South Carolina State War Fund Campaign in 1944. (Photo courtesy of Margaret and Linden Smith.)

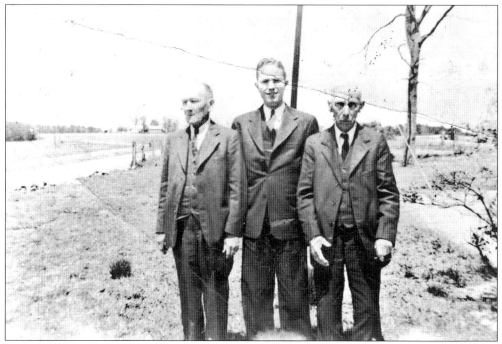

Three generations of Jackson men are pictured in this April 13, 1940 photograph. They are Fred Jackson, Joe Jackson, and Billy Joe Jackson. The Jackson family is descended from David Jackson and Mary Morrison Jackson, who left Ireland in 1774 and became some of the first settlers in the Clover area. (Photo courtesy of Margaret Jackson Woods.)

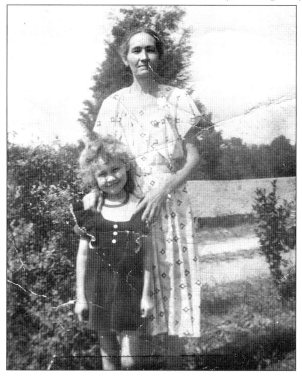

Nellie Whitworth stands with her daughter Joanne at their home on Beamguard Road in the 1940s. Prior to 1940, the Whitworth family lived on the Kings Mountain battleground, where American Patriots defeated Loyalist forces during the Revolutionary War. The Whitworths, who had seven children, still lived on the mountain when President Hoover visited in 1930 to celebrate the 150th anniversary of the battle. (Photo courtesy of Sherman and Joanne Moses.)

Like many other young men in the Clover area, James Lindsay Smart served in the U.S. Navy during World War II. (Photo courtesy of Margie Smart.)

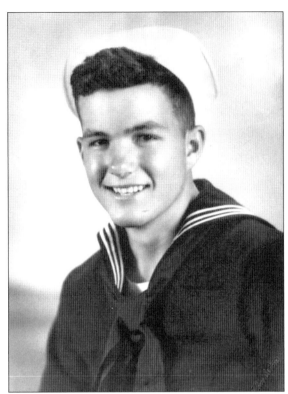

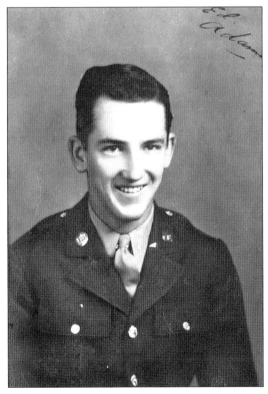

Ed Adams proudly wears his uniform in this photograph. (Photo courtesy of Sara L. Jackson.)

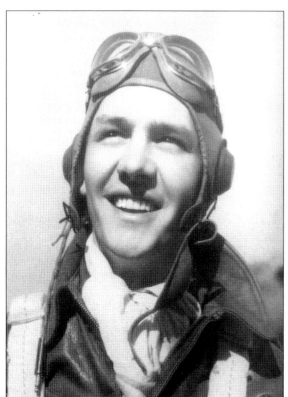

It was a proud moment for J.M. Wylie, who in 1941 was a 23-year-old graduate of Class 41 C Flying Cadets. Wylie, who was born in 1918, fought in World War II. He went on to serve in the South Carolina House of Representatives from 1946 to 1948. (Photo courtesy of Jim Wylie.)

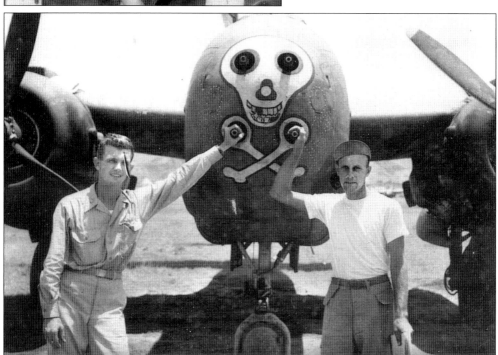

Wylie and an unidentified man stand in front of an A-20 Havoc in late 1945 or early 1946. (Photo courtesy of Jim Wylie.)

Margaret and Howard "Boot" Clinton were married December 26, 1945, after Howard returned from serving in World War II. Clinton was a member of Co. I 119th Infantry 30th Division. At the age of 23 he was reported missing in action, but a week later, it was determined that Clinton had been liberated and would return to the States. (Photo courtesy of Brent Clinton.)

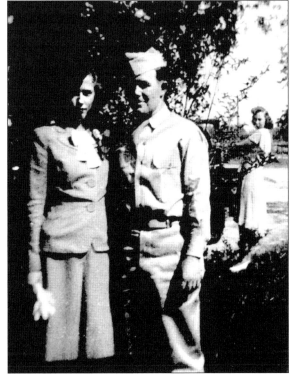

These young men were dressed in their Sunday best in the 1940s. They are, from left to right, Harold Robinson, Gene Robinson, Clarence Robinson, Claude Robinson, and Fred Robinson. (Photo courtesy of Claude and Frances Robinson.)

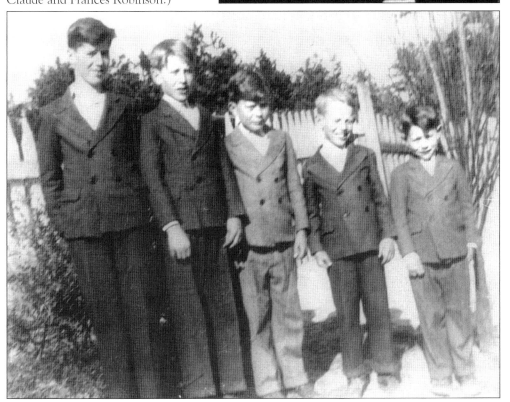

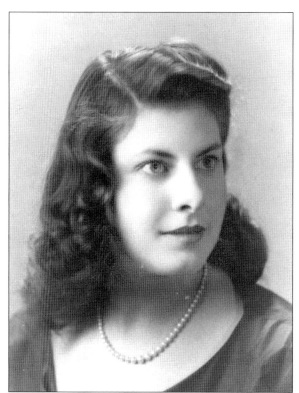

This is a 1950s portrait of Sue Kirsh, wife of state representative Herb Kirsh (D-Clover). Herb Kirsh was a child when his family moved to Clover in 1937 and opened Kirsh Department Store. (Photo courtesy of Herb Kirsh.)

James Goforth and James Byrd took a trip to the North Carolina mountains in 1950. Their dates snapped this photo outside the Fountain Shop in Chimney Rock. (Photo courtesy of James and Peggy Byrd.)

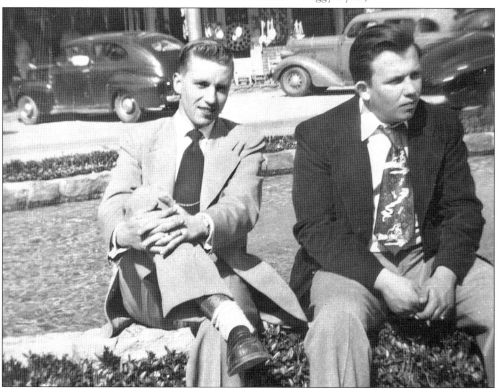

Many young men in the Clover area joined the Armed Forces. Sherman Moses was in the navy.

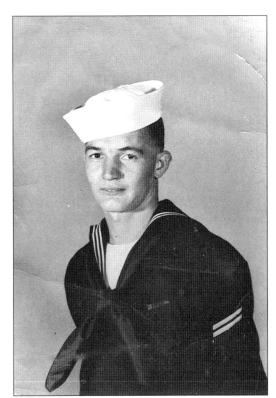

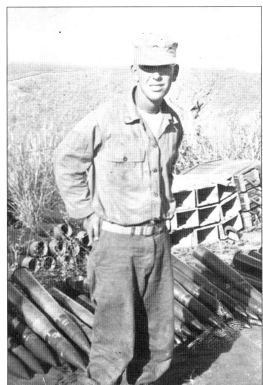

Claude Robinson, who was raised in Clover, served in the Marines. In this 1955 photograph, Robinson is at a USMC Naval Bombing range off of the east coast of Puerto Rico. (Photo courtesy of Claude and Frances Robinson.)

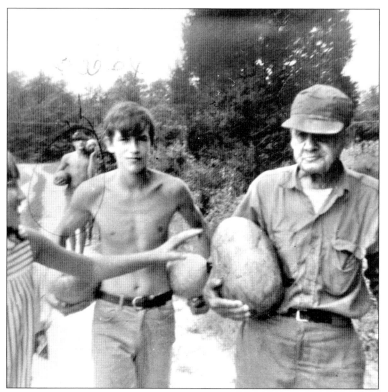

Rufus Franklin Whitworth and several of his grandchildren carry freshly picked watermelons from their garden. Whitworth and his wife Nellie farmed their land, but Whitworth also worked as a carpenter. (Photo courtesy of Sherman and Joanne Moses.)

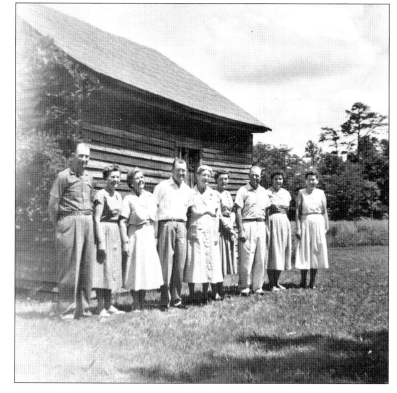

Clinton family members gather for a reunion in the 1950s. They are standing in front of a corncrib or smokehouse, familiar sights for most Clover residents of that time. (Photo courtesy of Brent Clinton.)

This photograph was taken outside the Campbell house, now the Clinton house, in the 1950s. Pictured from left to right are Nell Barnett, Howard "Boot" Clinton, Margaret Clinton, John Clinton, Campbell Barnett, and Leslie Clinton. (Photo courtesy of Brent Clinton.)

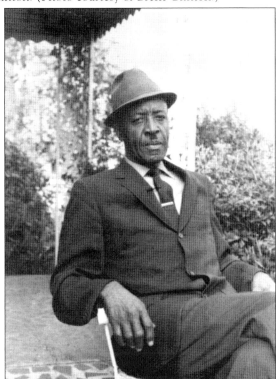

Jim Bratton relaxes in his yard in Clover. Bratton, who served in World War II, worked for the town of Clover. (Photo courtesy of Sara L. Jackson.)

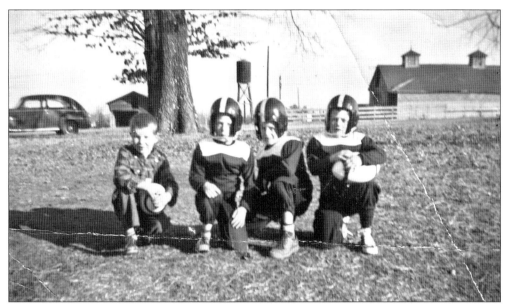

Christmas 1954 brought these boys outside with their football equipment. Pictured from left to right are Andy Clinton, John Clinton, Les Clinton, and Campbell Barnett. The tower in the background of this photograph was a gravity-fed water source that brought water from a nearby creek. (Photo courtesy of Brent Clinton.)

Pictured here is Walter McConnell's old home on Smith Road, c. 1956. The house no longer stands. Dan, Pat, and Mike O'Neal are playing in the yard near the car. (Photo courtesy of Clara Faye and Columbus Stiles.)

Columbus "Shorty" Lum Stiles is styling in the summer sun in this 1959 photo. (Photo courtesy of Clara Faye and Columbus Stiles.)

Columbus "Shorty" Stiles is shown c. 1960. Shorty's family moved to Clover in 1944, and he married Clara Faye O'Neal in 1961. Shorty has worked for the town of Clover for almost 24 years. (Photo courtesy of Clara Faye and Columbus Stiles.)

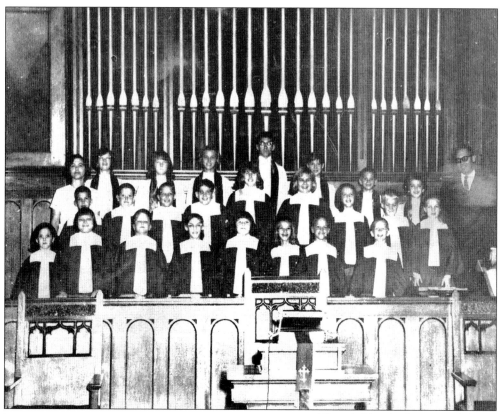

This children's choir raised their voices in song at Clover Presbyterian Church around 1965 or 1966. (Photo courtesy of Adelle Edmunds.)

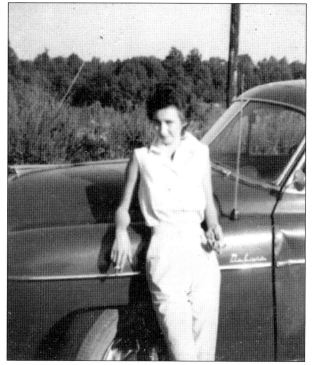

Clara Faye O'Neal Stiles stands beside an early-1950s Chevrolet in 1965. Faye's family moved to Clover in 1951, and she married Columbus "Shorty" Stiles in 1961. They have two children, Jerry and Tracy Stiles. (Photo courtesy of Clara Faye and Columbus Stiles.)

Clara Faye O'Neal Stiles sits on her front porch at 103 Claremont Street in 1967. The house in the picture is no longer standing. (Photo courtesy of Clara Faye Stiles.)

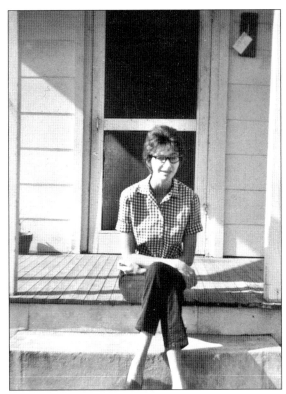

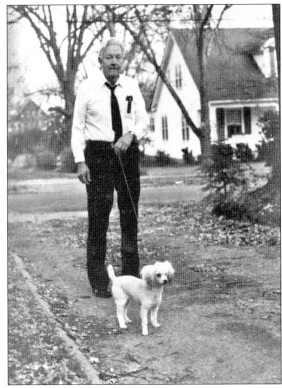

J.M. Wylie walks his daughter-in-law's poodle Lisette outside his Calhoun Street home in the 1980s. (Photo courtesy of Jim Wylie.)

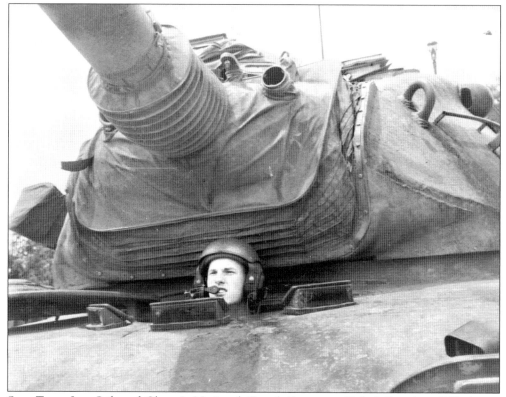

Spc. Tracy Lee Stiles of Clover's National Guard Company C 2nd Battalion 263 Armor Division is shown on tank maneuvers in Fort Knox, Kentucky, c. 1990. (Photo courtesy of Tracy Lee Stiles.)

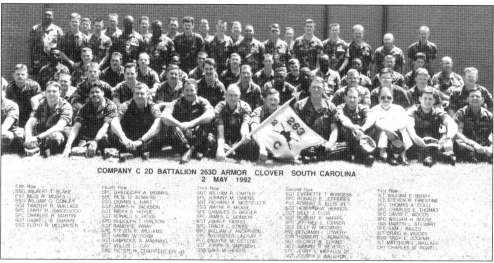

COMPANY C 2D BATTALION 263D ARMOR CLOVER SOUTH CAROLINA
2 MAY 1992

Fifth Row
SSG WILBERT T. BLAKE
PV2 BILLY W. MOSES
SSG WILLIAM G. CONLEY
SGT TIMOTHY R. WALLACE
SPC LARRY M. SWICEGOOD
SPC CHARLES R. MARTIN
SGT HASKELL B. SHARPE
SSG FLOYD R. McCARTER

Fourth Row
SPC GREGORY A. MORRIS
SPC PETE O. BOWERS
SSG DENNIS L. HART
SGT JAMES H. JACKSON
SGT RICKY S. HOYLE
SGT RONALD S. HOVIS
SPC RUDOLPH T. PHILSON
SGT RANDY E. WRAY
SPC STEVEN E. WILLIAMS
SGT SAMMY W. COOK
SGT ELDRIDGE A. MANNING
SGT WILLIS C. GAY
SPC PETER H. CHARPENTIER JR

Third Row
SGT WILLIAM R. CARTER
SPC JOHNNY M. OWENS
SGT RICHARD A. MOSTELLER
SSG WAYNE P. MEASE
SPC CHARLES D. BIGGER
SPC JAMES G. SEAMON
SGT JOHN F. FARRIS
SPC TRACY L. STILES
SPC WILLIAM J. ANDERSON
SPC SYLVESTER LINDSAY
PFC DWAYNE M. GETTYS
SGT JERRY D. SAPOUGH
SPC DALE W. HEDGE

Second Row
SGT EVERETTE T. BURGESS
SFC RONALD B. JEFFERIES
PV2 ROBERT S. ELLIS JR.
SGT HOWARD W. HERRON
SGT BILLY J. ELLIS
SGT ROBERT R. HARRIS
SPC JEFFREY H. TURNER
SGT BILLY W. McDANIEL
PV2 BENJAMIN J. LOWERY
SSG HERBERT L. ROBERTS
SGT GEORGE L. ELKINS
SGT JOHNNY P. BEVERLY
SPC JERRY L. McFALLS JR
SGT JOSEPH J. WALDRON

First Row
2LT WILLIAM E. BERRY
1LT STEVEN R. FIRESTINE
SFC THOMAS A. COLLI
SFC CHARLES E. THOMAS
SFC DAVID C. WOODS
SFC WILLIAM H. ROUSE
1SG MARTIN L. STEWART
SFC SAM J. BAILES
2LT CRAIG A. WOODS
SSG TROY E. COOPER
1LT MATTHEW J. WALLACE
CPT CHARLES W. POWELL

This is a 1992 picture of Clover's National Guard Company C 2nd Battalion 263 Armor Division. The unit was on standby for Desert Storm (1990–1991). The Clover company became part of an engineering unit in late 1995. Many members of the unit served in Iraq in 2003–2004. Spc. Tracy Stiles, a tank driver, is pictured in the third row. (Photo courtesy of Tracy Lee Stiles.)

Two

EDUCATION AND SPORTS

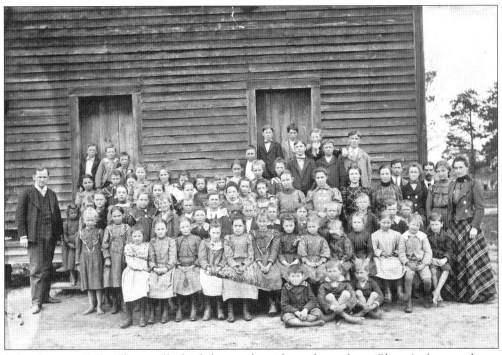

Schoolmaster Earle Thornwell, far left, stands with students from Clover's first academy, c. 1896. Clover Academy was operated by Clover Presbyterian Church and was located on the east side of the church on Kings Mountain Street. (Photo courtesy of Margaret and Linden Smith.)

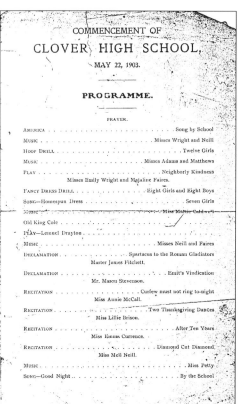

This Clover High School program announced the commencement exercises for May 22, 1903. (Photo courtesy of Margaret and Linden Smith.)

This is a *c.* 1910 picture of Clover's school on Pressly Street, which students attended from first grade through graduation. Additions would later be made to the school, but by the mid-1960s, the building was demolished. Jim Wylie, who lived across the street from the old school, enjoyed his short walk to school just moments before the bell rang. Today, Kinard Elementary School is located on the site of the old school, with Cathy McCarter as principal. (Photo courtesy of Jim Wylie.)

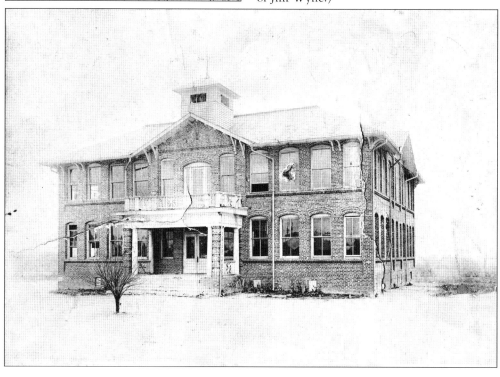

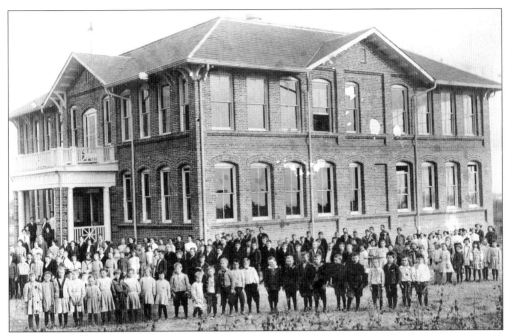

This photograph of Clover School was taken in 1910. Clover residents attended this school until the mid-1960s, when it was demolished. Currently, Clover has four elementary schools, an elementary-middle school, a middle school, a junior high school, and a high school. There is also an auditorium and Applied Technology Center in the Clover School District. (Photo Courtesy of Ed Stewart.)

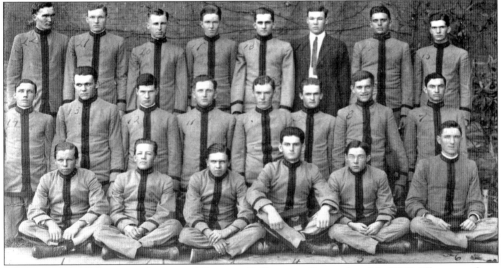

York County students are shown at Clemson College on September 18, 1913. They are, from left to right, (front row) R.H. Glenn, A.A Barron, T.L. Glenn, O.E. Ford, W.W. Barron, B.C. Blankenship; (middle row) F.T. Buice, W.T. Slaughter, H.S. Henry, T.M. Ferguson, C.J. Goulden, S.H. Wilkerson, T.B. Brandon, F.M. Howell; (back row) W.B. Wilkerson, C.D. Brandon, W.A. Matthews, E.B Garrison, E.H. Garrison, J.H. Steele, J.B. Kendrick, and M.S. Barnette. O.E. Ford and H.S. Henry, both Clover residents, roomed together in 1913 and 1914. (Photo courtesy of Ed Stewart.)

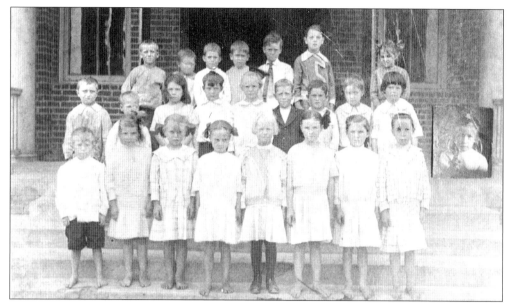

This photograph of a first grade class was taken in April 1914. They are, from left to right, (front row) George Bailes, Lillian Adams, Irene Jenkins, Ethel Dickson, Catherine Matthews, Addie Mae Camp, Maude Jackson, Emily Sifford; (middle row) Stonewall Hopper, Fred Dickson, Margaret Clinton, Clauston Jenkins, Christine Smith, Clarence Knox, unidentified, Mike Smith, Annie Mae Price; (back row), Raymond Adams, Boyce Robinson, Philip Jackson, Eugene Barrett, Edward "Buck" McCall, Betty Turner, and Annie Barrett. The inset is Martha Jackson. (Photo courtesy of Margaret and Linden Smith.)

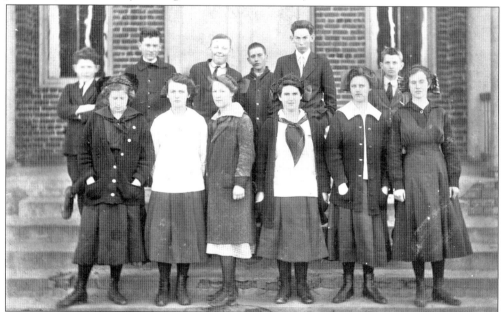

Shown here is a 1916–1917 class at Clover School. Pictured are, from left to right, (front row) Frances Smith, Lois Moore, Annie Sifford, Alice Ford, Louisa Moore, Aliene Robinson; (back row) Oddis Robinson, Herbert Smith, Gray McElwee, Ennis Jackson, Claude Pursley, and James Page. (Photo courtesy of Margaret and Linden Smith.)

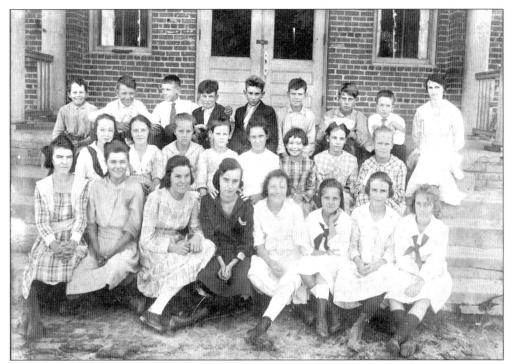

This *c.* 1917 Clover School class is, from left to right, (front row) Iva Neely, Annie Barrett, Cleo Henry, Janie Stewart, Lois Maxwell, Grace Campbell, Josie McElwee, Lena Pursley; (middle row) Susie Wood, Marie Jackson, Ellie Jackson, Clara Stacy, Lucy Robinson, Martha Hogue, Lillian Barber, Evelyn Mathews; (back row) Ladd Maxwell, LeRoy McCall, Lindsay Stacy, Cecil Barrett, Paul Ritch, unidentified, Ross Robinson, Edward Smith, and the unidentified teacher. (Photo courtesy of Margaret and Linden Smith.)

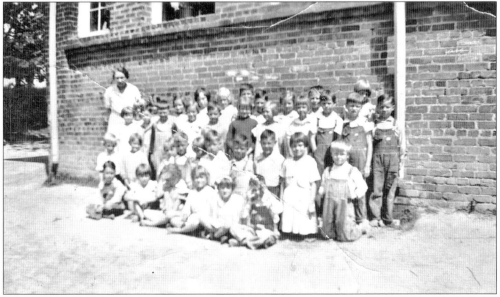

Teacher Lila Jackson and her first grade class pose for a picture at the Clover School in this undated photo. (Photo courtesy of Sara L. Jackson.)

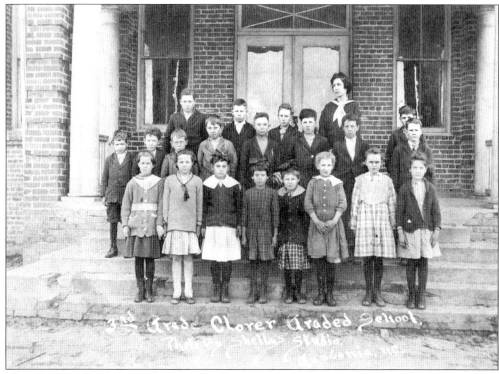

This third grade class at Clover School poses with teacher Miss Pearle Williams. (Photo courtesy of Sarah B. Jackson.)

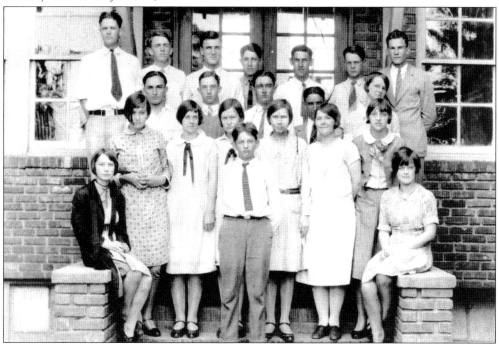

A seventh grade class at Clover High School poses in this undated photograph. (Photo courtesy of Sarah B. Jackson.)

The 1925 Clover yearbook, *The Terror*, was dedicated to Miss Marion Jane Smith, a school staff member. In the 1940s, the Clover School yearbook was entitled *The Lucky Leaf*, and by 1950 it was named *The Blue Eagle*. (Photo courtesy of York County Culture and Heritage Commission.)

Pictured are faculty members from the 1925 Clover yearbook. The Clover School was located on Pressly Street and was attended by all grades. (Photo courtesy of York County Culture and Heritage Commission.)

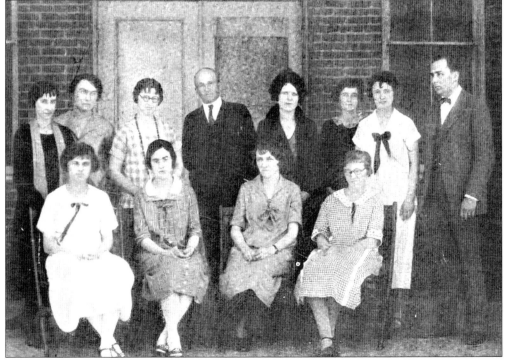

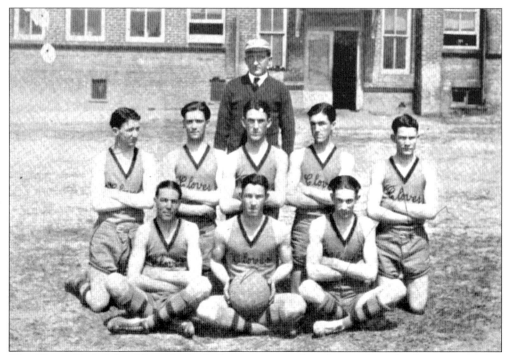

The Clover High School boys' basketball team, pictured in the 1925 yearbook, was a member of the Catawba Association. Members of the team include, from left to right, (front row) Hoyt Hambright, Harry Beamguard, Paul Ritch; (middle row) Marshall Neil, Edward "Buck" McCall, Clarence "Bull" Perry, Fred Ferguson, James Ritch; (back row) Coach Tatum. (Photo courtesy of York County Culture and Heritage Commission.)

This is the Clover School after additions were made. Located on Pressly Street, this building was torn down in 1965 or 1966. Today, Kinard Elementary School is located at the old Clover School site. (Photo courtesy of Ed Stewart.)

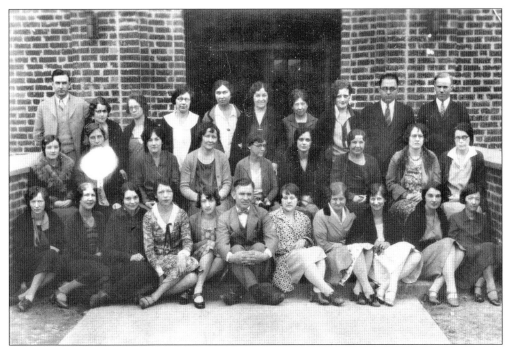

Faculty members of Clover School pose for a photograph in the 1930s. (Photo courtesy of Ed Stewart.)

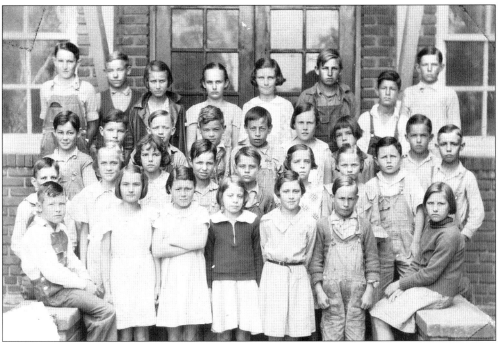

This photograph was taken outside the Clover School on Pressly Street in the 1930s. (Photo courtesy of Adele Edmunds.)

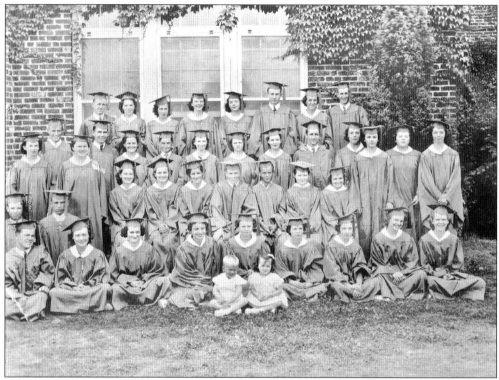

The class of 1938 had plenty to smile about when they graduated from Clover High School. The young mascots are Billy Dulin and Betsy Campbell. (Photo courtesy of Brent Clinton.)

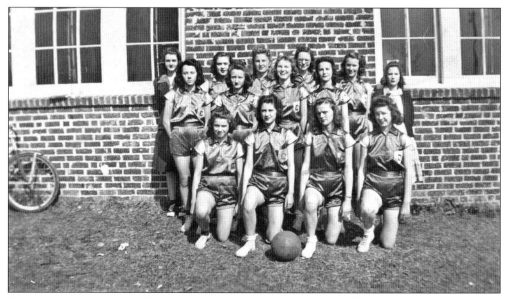

The Clover girls' basketball team smiles for the camera, c. 1940. Sara L. Jackson stands third from left. (Photo courtesy of Sara L. Jackson.)

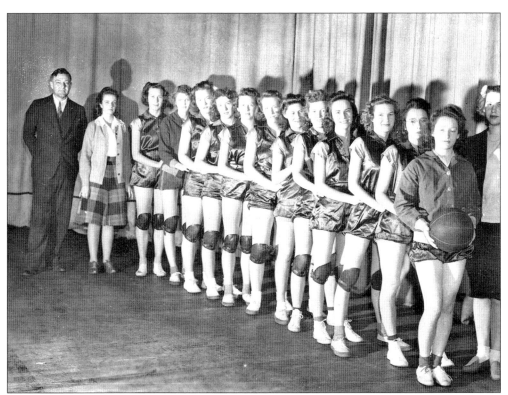

These enthusiastic girls were members of the Clover High School basketball team in 1944. (Photo courtesy of Herb Kirsh.)

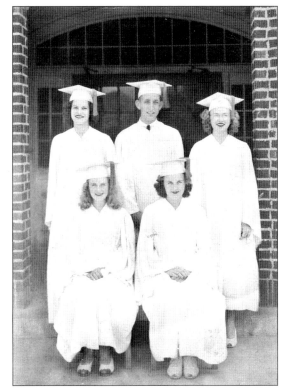

These 1945 students graduated from Clover High School with honors. They are, from left to right, (sitting) Elizabeth Stewart, Ada Ford; (standing) Elizabeth Stanton, Billy Gray, and Reba Jenkins. (Photo courtesy of Herb Kirsh.)

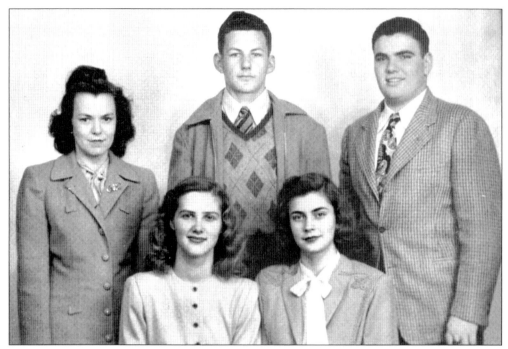

The 1946 Clover High School Debaters team is, from left to right, (seated) Evelyn Gettys, Estelle Chariker; (standing) ? Graves, Jimmy Pursley, and Herbert Kirsh. (Photo courtesy of Herb Kirsh.)

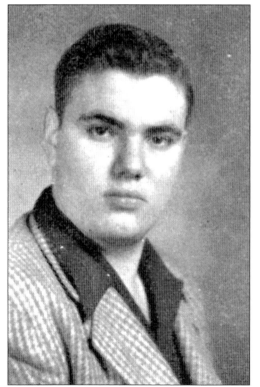

State representative Herb Kirsh (D-Clover) is shown in his senior year at Clover High School. Kirsh was a child when his family moved to Clover in 1937 and established Kirsh Department Store. Kirsh, born May 17, 1929, in New York City, is a former Clover mayor and has served in the State House of Representatives for more than 20 years. When he is not in the state capitol, Kirsh can usually be found in his office on Main Street. (Photo courtesy of Herb Kirsh.)

arge to the account of _____ $ _____

WESTERN UNION

1217

A. N. WILLIAMS
PRESIDENT

nd the following telegram, subject to the terms on back hereof, which are hereby agreed to

CHECK

ACCOUNTING INFORMATION

TIME FILED

**FOR VICTORY
BUY
WAR BONDS
TODAY**

CFR 14 SIX EATRA DUP MSG DLD FM GASTONIA CFMD
NEW YORK N Y 830 AM MAY 26 1946

HERBERT KIRSH
CLOVER SO CAR

CONGRATULATIONS WE ARE VERY PROUD OF YOU LOVE.

AUNT SADIE AND UNCLE SAM

838 AM 27

State representative Herb Kirsh (D-Clover) saved this 1946 Western Union telegram from his aunt Sadie and uncle Sam congratulating him for graduating from Clover High School. During his high school career, Kirsh, an honor graduate, played football and was a member of the Block C Club, the paper staff, debate team, and the National Honor Society. (Photo courtesy of Herb Kirsh.)

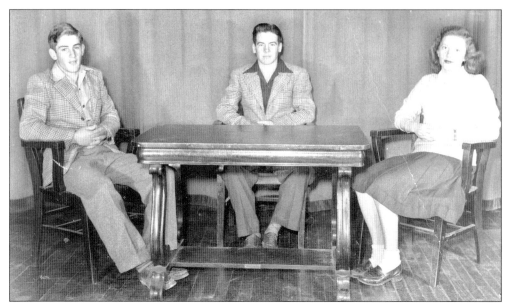

Seated around the table in this photograph are the Clover High School Senior Class Officers of 1947. They are Bob Ferguson, who played football and basketball; Pat Harvey, who played football, baseball, and basketball; and Buddy Barber, who played basketball and was a cheerleader and a member of the Glee Club. (Photo courtesy of Herb Kirsh.)

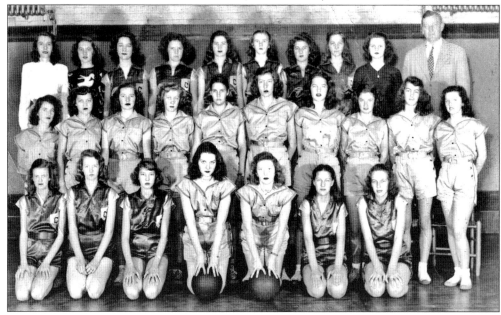

The 1947 girls' basketball team are, from left to right, (kneeling) Beth Burns, Becky Faulkner, Nell Carroll, co-captain Kitty Gettys, co-captain Buddy Barber, Betty Carpenter, Jean Love; (middle row) Cynthia Harvey, Betty Lou Bailey, Jean Goforth, Rachel Turner, Jean Sistare, Dot Lawrence, Thelma Hopper, Peggy Henry, Martha Pursley, Barbara Maxwell; (back row) Mrs. Lanier, manager Ford, Gwendolyn Leagan, Jeanette Munday, Nancy Glenn, Mary Stroup, Betty Murphy, Dot Craig, manager Biggers, and coach Jenks Caldwell. (Photo courtesy of Herb Kirsh.)

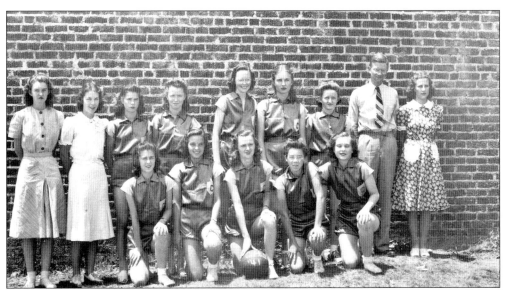

Basketball was a popular sport for girls at Clover High School in the late 1940s. Other activities for students included the Glee Club, Block C Club, Junior Homemakers of America, and Future Farmers of America. (Photo courtesy of Herb Kirsh.)

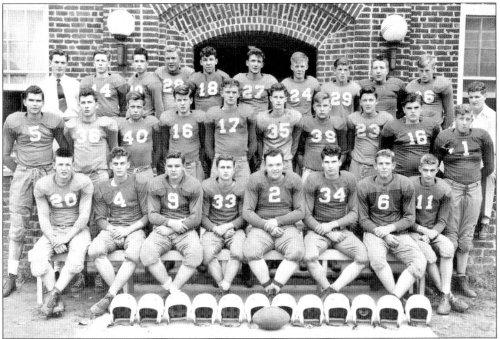

This late-1940s Clover High School football team is, from left to right, (first row) Ralph Harper Jr., Jack Westmoreland, William Penley, Billy Hopper, John Smith, William Goforth, Jack Quinn, Floyd Parrish; (middle row) Richard Chariker, Joe Curry, James Byrd, Ted McCarley, John Barnett, Eugene Bowman, Alan Boyd, Joe McElwee, Joe Hammond, Ed "Bud" Faulkner; (back row) coach H.E. Corley, Jim Daughdrill, Richard Grayson, unidentified, Joe Spears, James Pettus, Ted Westmoreland, "Rabbit" Lewis McCarter, Marshall Boyd, Charles Ferguson, and Max Freeze. (Photo courtesy of James and Peggy Byrd.)

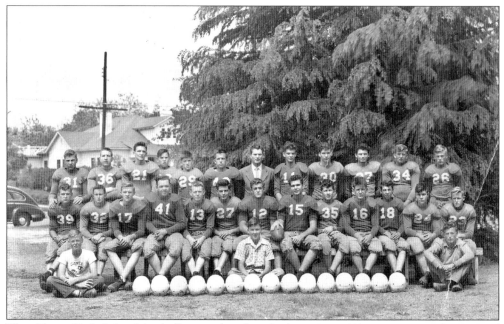

This Clover High School football team played in the late 1940s. (Photo courtesy of James and Peggy Byrd.)

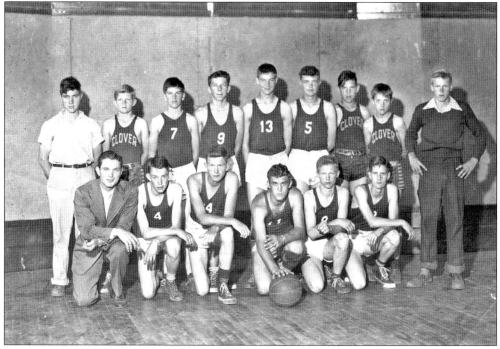

This late-1940s Clover High School basketball team is, from left to right, (front row) coach H.E. Corley, Ralph Ramsey, unidentified, Tommy Robinson, Dean White, Eugene Bowman; (back row) Kenneth Chariker, Billy Wallace, Lewis McCarter, Joe Spears, Floyd Parish, Jimmy Pendleton, Melvin Hopper, John Blanton, and Bobby Whitener. (Photo courtesy of James and Peggy Byrd.)

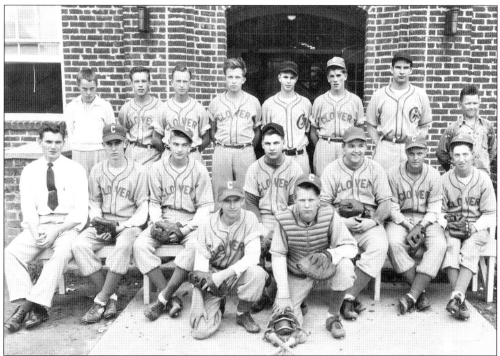

The 1949 Clover High School baseball team was District Champs. They are, from left to right, (kneeling) Wilmer Earle, Dean White; (seated) coach H.E. Corley, Watt Moore, Floyd Parrish, Allan Boyd, John Smith, Jimmy Pendleton, Webster Grayson; (standing) manager John Blanton, Boyce Wells, Bobby Graham, James Byrd, Harry Farris, Lewis McCarter, William Goforth, and manager Richard Bolin. (Photo courtesy of James and Peggy Byrd.)

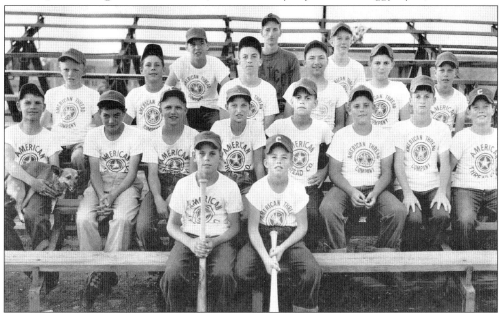

The boys in this photograph, c. 1950, played ball for American Thread Company. (Photo courtesy of Sherman and Joanne Moses.)

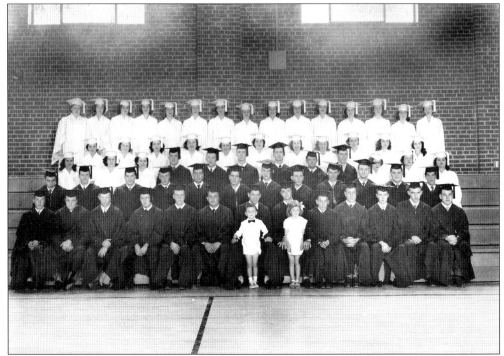

Clover High School graduates pose proudly for the camera. Students were involved in academics, sports, clubs, and band. The class flower for 1951 was the red rose, the class colors were red and white, and the class motto was "after the battle—the reward." (Photo courtesy of James and Peggy Byrd.)

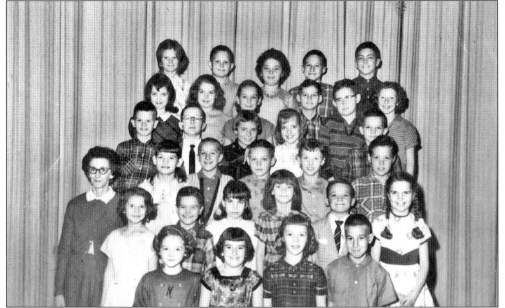

This fourth grade class picture was taken at Clover School during the 1961–1962 school year, several years before the school was demolished. Mrs. Mary McCarter Neil was the teacher. (Photo courtesy of Jim Wylie.)

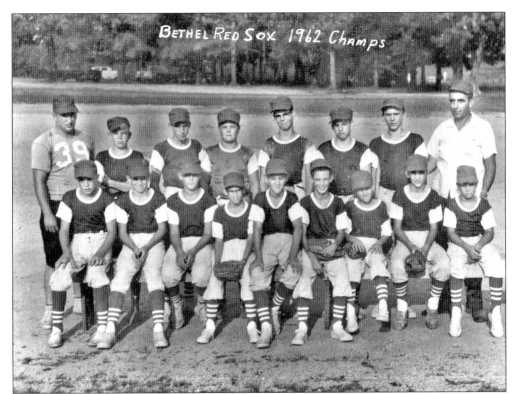

Bethel Red Sox 1962 Champs

The champion 1962 Bethel Red Sox are, from left to right, (front row) John Clinton, Perry Johnson, Smith Dickson, Don Robinson, Roger Griggs, Marion Robinson, David Sims, Ricky Cobb, Jimmy Killian; (back row) coach James McCarter, Andy Clinton, Algie Sims, Campbell Barnett, Jerry Glen, David Johnson, Mac Johnson, and coach William Dickson. (Photo courtesy of Brent Clinton.)

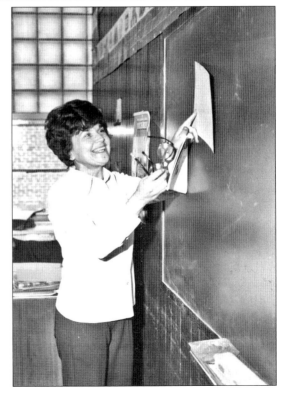

Margaret Jackson teaches in her classroom at Clover Middle School. During the 1943–1944 school year, she taught at Clover School and was one of seven teachers who boarded with Mrs. Lena Smith across from the school. The teachers were know as the Single Seven and included Evelyn Smith, Ruth Burts, Miriam Buice, Rachel Windell, Florrie Tweedy, Ruth Brown, and Margaret Buice Jackson Woods. (Photo courtesy of Margaret Jackson Woods.)

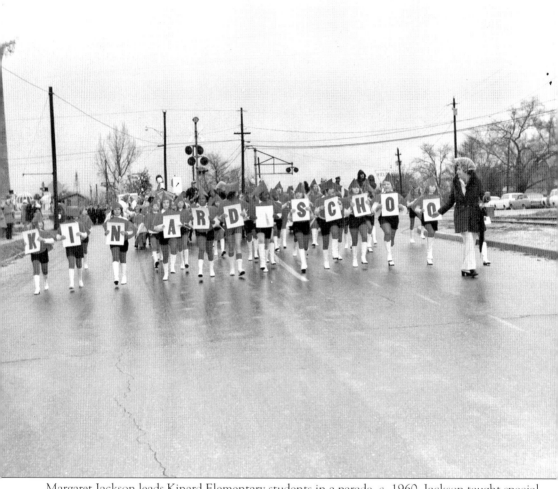

Margaret Jackson leads Kinard Elementary students in a parade, c. 1960. Jackson taught special education for many years in the Clover School District and worked diligently to offer her students many opportunities. She accompanied a student to Los Angeles so he could participate in track events at the Special Olympics. (Photo courtesy of Margaret Jackson Woods.)

Three
BUSINESS AND INDUSTRY

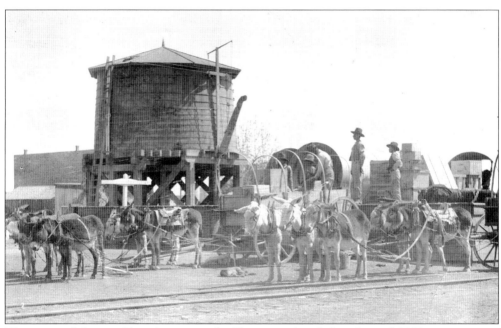

This postcard depicts Clover's water tank. Clover was founded in the mid-1870s as a watering station for steam engines on the Chester and Lenoir Narrow-Gauge Railroad. A wooden water tank that held 5,000 gallons of water was built on what is now South Main Street. There are different stories as to how Clover got its name, but one legend says the tank often overflowed and a patch of clover flourished under the water tank. It is said that train crews looked forward to stopping at the "Clover Patch" to look for four-leaf clovers. Others researchers say Clover was given its colorful name in an effort to attract newcomers to the fledgling town. (Postcard courtesy of York County Culture and Heritage Commission.)

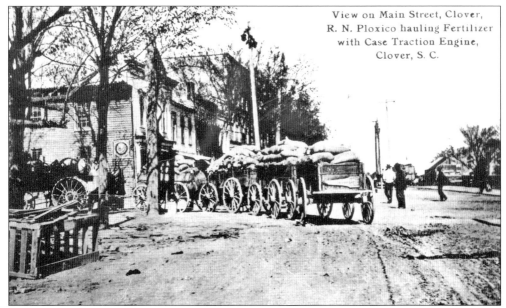

View on Main Street, Clover,
R. N. Ploxico hauling Fertilizer
with Case Traction Engine,
Clover, S. C.

This photograph shows Clover's Main Street before it was paved. Fertilizer was being hauled that day with a case traction engine. (Photo courtesy of Ed Stewart.)

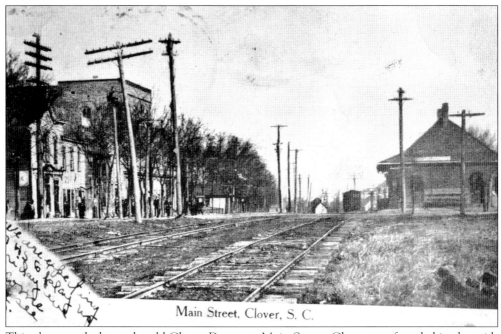

Main Street, Clover, S. C.

This photograph shows the old Clover Depot on Main Street. Clover was founded in the mid-1870s as a watering station for steam engines on the Chester and Lenoir Narrow-Gauge Railroad. (Photo courtesy of Ed Stewart.)

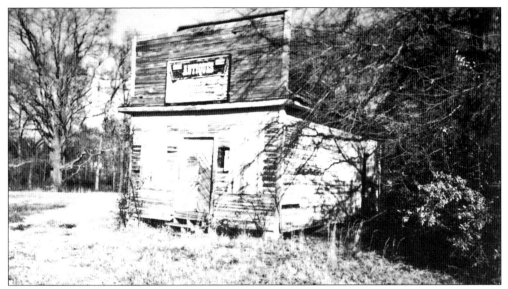

This wooden structure was Clover's first post office building. Josiah I. Gwinn, the town's postmaster, constructed the building, which was heated with a pot-bellied stove, on Main Street in 1884. Gwinn served as postmaster for 30 years. Additions were later made to the one-room post office, which has been moved twice. It is currently located on Church Street. (Photo taken by Karan M. Robinson.)

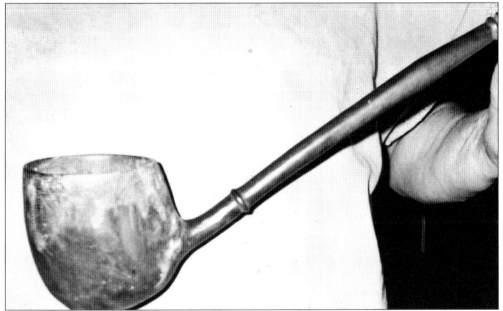

This cherry dipper was carved by Samuel L. Campbell, a Confederate soldier who was wounded and blinded in Maryland. During battle, Campbell was hit in the left eye with a "minnie" ball, which exited his right ear. A Maryland family cared for him until he was well enough to return home to his wife in Clover. "Blind Sam," as he was called, worked at Clover's railroad station pumping water; in his spare time, he whittled and carved items with his pocketknife and gave them away or sold them. James Ebenezer Matthews gave the wooden dipper pictured here to J.M. Wylie, who passed it on to his son, Jim Wylie. (Photo courtesy of Karan M. Robinson.)

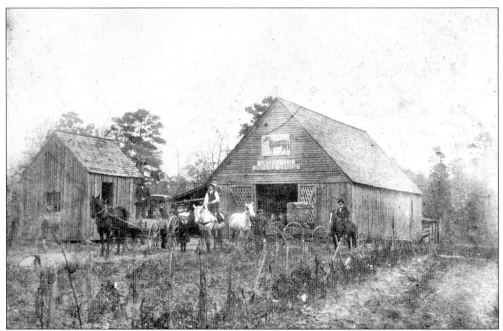

Andy Gwinn owned this livery stable, as well as a general merchandise store where the post office was located. Mr. Gwinn, who was justice of the peace, later became postmaster. Clover's Gwinn Street is named after him. (Photo courtesy of Ed Stewart.)

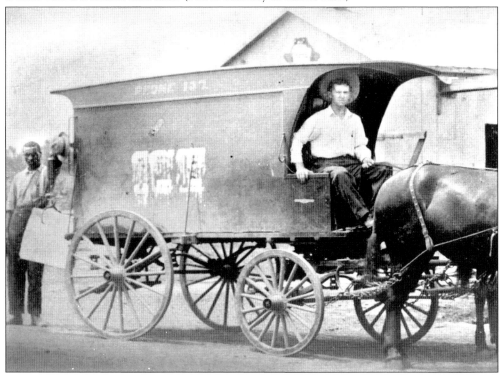

Two unidentified men deliver ice in Clover, *c*. 1910. (Photo courtesy of York County Culture and Heritage Commission.)

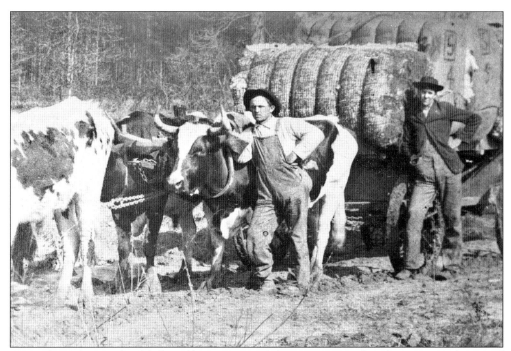

Two Clover farmers haul bales of hay, *c.* 1910. (Photo courtesy of York County Culture and Heritage Commission.)

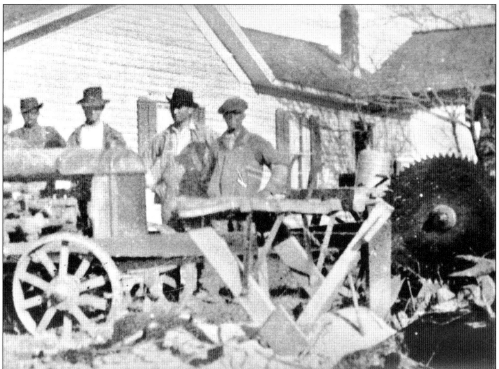

This is a 1910 photograph of a local blacksmith shop, possibly Knox's. (Photo courtesy of York County Culture and Heritage Commission.)

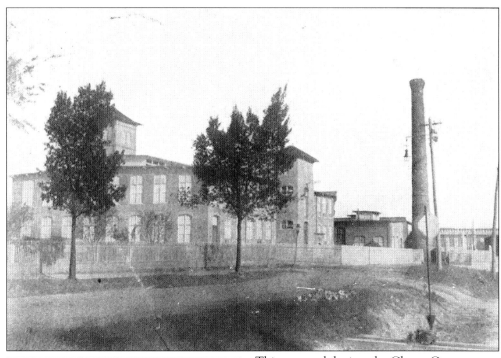

This postcard depicts the Clover Cotton Manufacturing Company in Clover. In 1882, Clover had approximately 70 residents, a few stores, a blacksmith shop, a post office, and a church. By 1890, the population had increased to 287, and in 1924 there were three mills in Clover. (Postcard courtesy of York County Culture and Heritage Commission.)

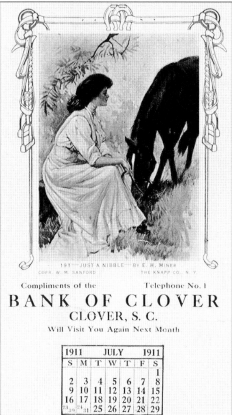

The Bank of Clover distributed this colorful calendar postcard in 1911. The back of the card urges men and women to keep track of their money by opening a checking account at the bank. (Postcard courtesy of York County Culture and Heritage Commission.)

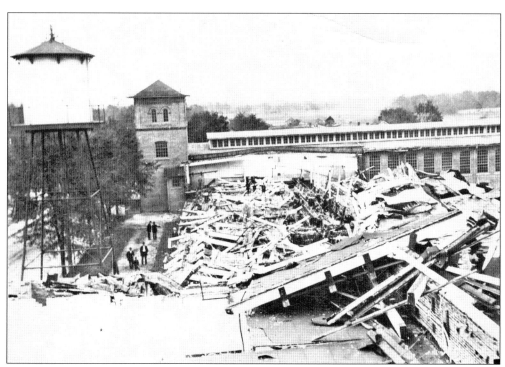

On August 3, 1912, a cyclone hit Clover and blew down a section of the Clover Cotton Manufacturing Company, which had been in operation since 1890. Capt. William Beatty Smith, who became known as the "founder of Clover," organized and built the mill. (Photo courtesy of Ed Stewart.)

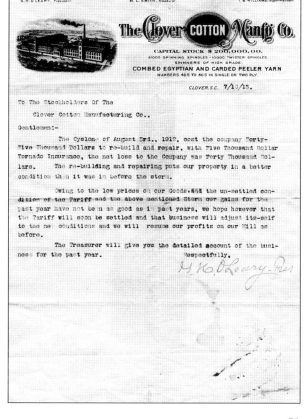

This 1913 letter describes the effects of the cyclone to stockholders of the Clover Cotton Manufacturing Company. Strong winds descended on Clover on August 3, 1912, damaging a section of the mill and costing the company $45,000. Because the storm hit on a Saturday when the mill was closed, no workers were injured. (Photo courtesy of Margaret and Linden Smith.)

Dr. J.W. Campbell was one of Clover's earliest doctors. He was born November 26, 1870. (Photo courtesy of Ed Stewart.)

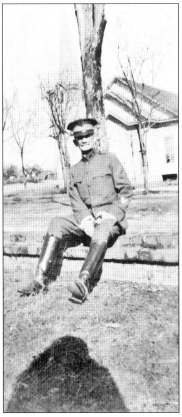

This is a photograph of Dr. E.W. Pressly during World War I. Dr. Pressly attended Maryland Medical College and came to Clover in 1887. He boarded with Mr. and Mrs. John J. Smith and, a year later, married their daughter, Harriet Louisa. Dr. Pressly, who also served as the doctor for the Clover Cotton Manufacturing Company, endeared himself to residents during his 44 years of service to the people of Clover. Dr. Pressly was born November 20, 1863, and died July 24, 1931. (Photo courtesy of Ed Stewart.)

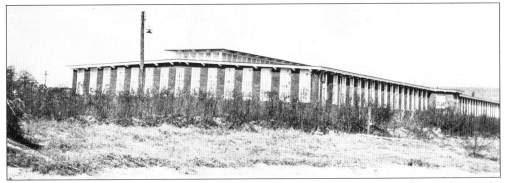

This photo shows the south end of Hawthorn Mill, named for Colonel Hawthorn, who fought at the Battle of Kings Mountain during the American Revolution. The mill was built in 1916 on South Main Street. The Hawthorn later became Hampton Spinning Company, and around 1942 the American Thread Company purchased the mill. (Photo courtesy of Margaret and Linden Smith.)

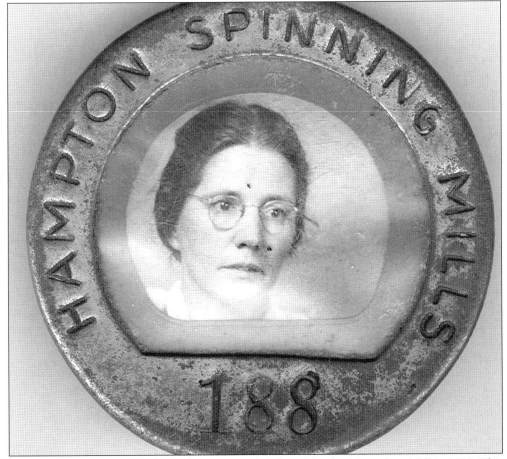

The Hawthorn Mill was built in Clover in 1916, followed by the Hampshire Mill in 1923. This badge was issued to Lola Smart, an employee of Hampton Spinning Mill. Around 1942, American Thread Company bought the Hawthorn and Hampshire Mills. (Photo courtesy of Margie Smart.)

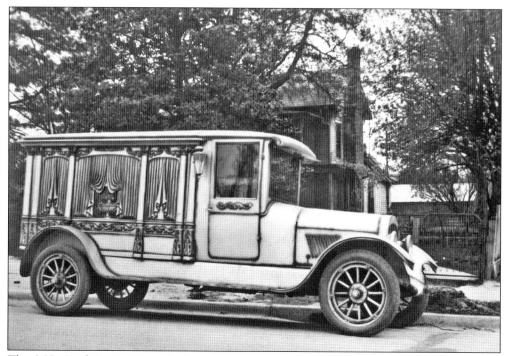

This M.L. Ford & Son Funeral Home hearse was one of the first motorized hearses in York County. The hearse is parked in front of the Ford home. When Marcus LaFayette Ford established M.L. Ford & Son, it was one of Clover's first businesses. M.L. Ford was born in Dallas, North Carolina, on August 20, 1852. (Photo courtesy of Ed Stewart.)

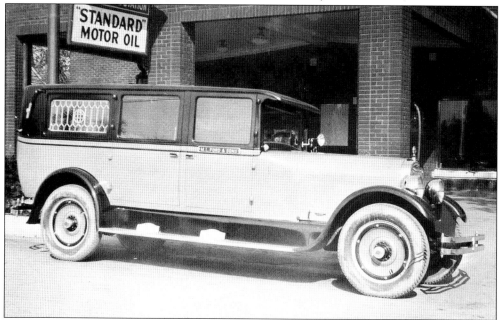

This hearse owned by M.L. Ford & Son is parked in front of Standard Motor Oil on Main Street. Today, NAPA Clover Auto Parts Inc. is housed in the building. (Photo courtesy of Ed Stewart.)

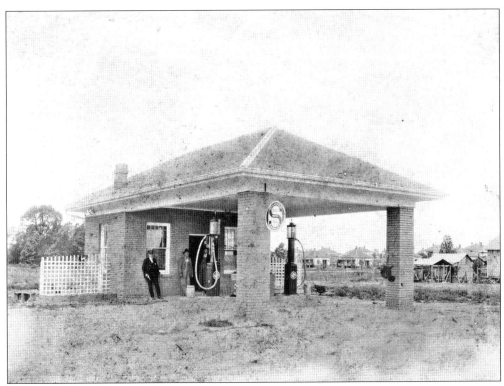

Police Chief Joe Youngblood and an unidentified man stand in front of the old Sinclair service station on Bethel Street in this undated photograph. Sinclair's was located in approximately the same spot where Poole Optometric office is located today. Although altered, Sinclair service station is still standing, but it has been moved to a private residence off of Bethel Street. (Photo courtesy of Ed Stewart.)

North Main Street and the Clover Cotton Manufacturing Company mill feature prominently on this undated postcard (Postcard courtesy of York County Culture and Heritage Commission.)

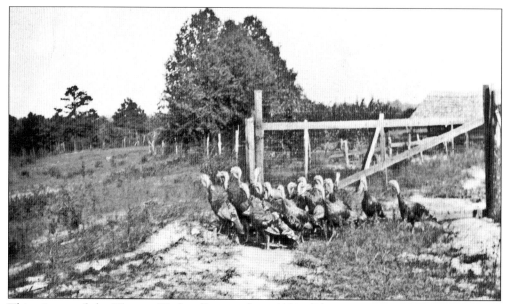

This picture of the Thomas Turkey Farm is from 1921. (Photo courtesy of Lib Thomas and Jonathan Thomas.)

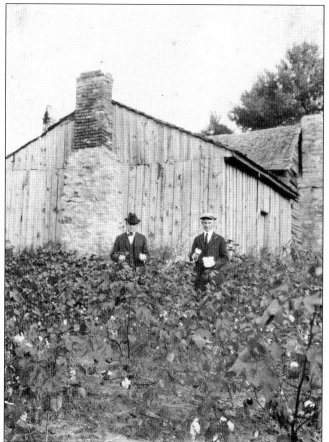

This photograph of Myles Linden Smith and Johnny Wood, c. 1928, was taken behind the Cotton Gin, located on Gin Street. The street, gin, and office no longer exist. Gin Street ran parallel to Kings Mountain Street behind the Clover Presbyterian Church and the homes on Kings Mountain Street. It ran west from what is now Church Street to Stella Street. The combination office and scale house for the gin was located in what is now the front yard of 205 Gwinn Street. The present clump of walnut trees on the site grew up around the foundation of the scales. The actual gin building was located west of the office.

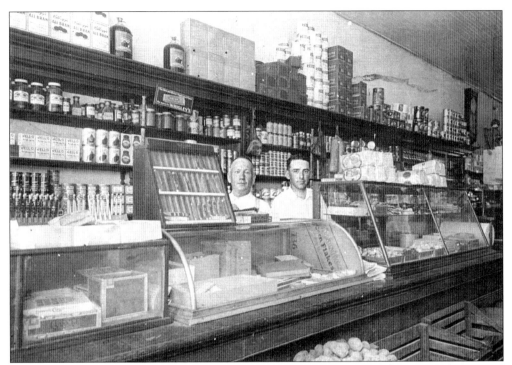

Mr. Fred H. Jackson, owner and operator of Fred H. Jackson Grocery, and Bernie Jackson stand behind the counter of the store. Fred Jackson entered the mercantile business in 1908, opening his own store sometime later. Fred ran his grocery business for 31 years. (Photo courtesy of Margaret Jackson Woods.)

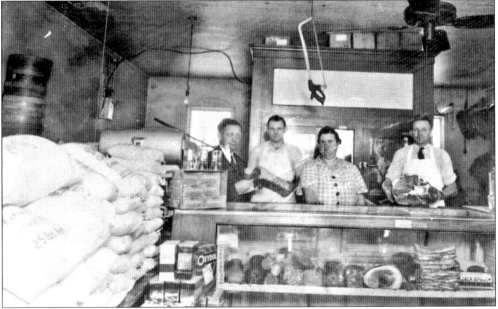

This photo was taken c. 1933 in what is now Jackson's Kitchen. From left to right are E.L. Adams, Campbell Jackson, Katie Bell Adams, and George Jackson. The Campbell brothers worked for E.L. Adams, their cousin. (Photo courtesy of Dickie Jackson.)

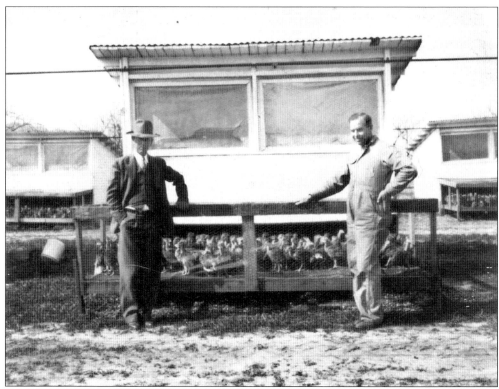

T.M. Thomas and John Fewell stand in front of turkey poults (young turkeys) on the Thomas Turkey Farm, c. 1930. (Photo courtesy of Lib Thomas and Jonathan Thomas.)

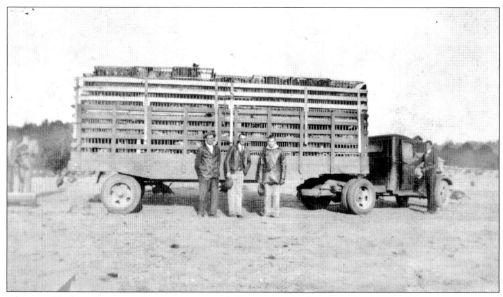

Thomas Turkey Farm workers prepare to deliver a load of turkeys in 1935. (Photo courtesy of Lib Thomas and Jonathan Thomas.)

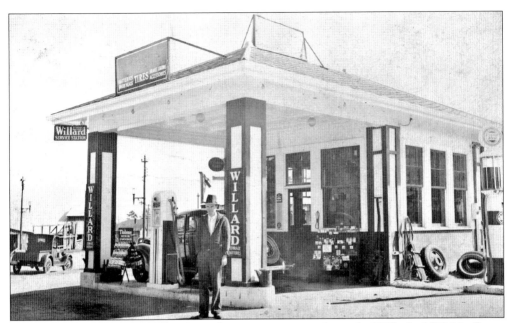

Leland Burns stands outside the Central service station in the early 1930s. In 1927 Mr. Burns bought the business from W.N. Jackson, for whom he had worked for two years. Central service station had two gas pumps and charged and sold batteries. In 1916, gas sold for 11¢ a gallon, but hand pumps were not available in Clover until 1917. Before that, gas was hauled from York to Clover and sold out of 50-gallon drums. (Photo courtesy of Sarah B. Jackson.)

LIONS CLUB

CLOVER, SOUTH CAROLINA

CHARTER NIGHT

FRIDAY, OCTOBER THIRTIETH

NINETEEN HUNERED THIRTY SIX

EIGHT O'CLOCK

CLOVER CITY HALL

Friday, October 30, 1936, marked the first meeting of the Lions Club in Clover. The 1936 officers included president E.H. Smith; vice presidents W.S. Patterson, W.K. McGill, and L.F. Abernathy; secretary-treasurer Pat H. Hobson; lion tamer W.W McConnell; tall twister W.W. Inman; and directors J. Meek Smith, W.G. Reid, and F.L. McElwee. (Photo courtesy of Margaret and Linden Smith.)

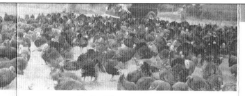

Feeding Time

Pullorum Control

...e are operating under the National Improvement ...; and all our breeders are tested by Turkey Spe-...ists from our State Agricultural College. Our ...chery received the rating of U. S. Approved-Pul-...m Controlled on first test, with a large number of ...flocks testing entirely clean. We are testing our ...ders at regular intervals throughout the season. ...s is one of your best assurances of getting poults ...will LIVE and GROW.

Hatchery

...e have one of the most modern and up to date Ex-...ve Turkey Hatcheries in the entire Country. We ...e 4 20D all electric especially built Petersime Tur-...Incubators. These machines are equipped with ...matic Humidifiers which give absolute control over ...sture conditions inside the machines. A very im-...ant factor in production of highest quality poults ...roper use of humidity.

...r Poults are not hatched by forced draft. Instead ...air is agitated by fans running around the entire ...n of eggs insuring an even distribution of heat, air, ...moisture throughout the entire incubator. Instead ...ach machine's being equipped with one or two ther-...eters, each of ours is equipped with 6 thermom-...s and 2 hydrometers. Each incubator has 4 ...ces of ventilation.

...l our machines are equipped with and our entire ...chery is proofed with Sterilamps which burn con-...ously. This is the latest scientific development for ...destruction of airborne germs. We also practise ...gid sanitary program of disinfecting and fumigat-...

...r Hatchery is half under ground and half above ...16 inch stone and concrete walls which insure ...nst any sudden change in Temperature and against ...mes in Temperature. The ventilation was designed ...competent ventilating engineer.

...r. Thomas personally operates these machines and ...in it all the experience and knowledge he has gained ...a 25 year period of hatching turkeys by artificial ...as.

...r Poults are boxed in Specially Built Turkey Boxes ...r Sterile Lamps. They are rechecked and shipped ...mmediately. We are 12 miles from Gastonia, N. C. ...h is on the Main Line of the Southern Railway and ...iles from Charlotte, N. C. Also 30 miles from Rock ...S. C. and 35 miles from Chester, S. C. We can ...poults from some of these points most any hour—...or night.

...e carry our poults to the station in a heated panel ...k or car. We see that they are properly taken care ...the station and are placed in a good position on ...rain.

...hen we ship poults out, we always WIRE the per-...receiving them telling when they were shipped ...where they were shipped to.

Guarantee

We guarantee 100% Live Delivery of the number of poults ordered. When a shipment falls below 100% of number ordered, have Express Agent make out a Joint Bad Order Report and mail to us Immediately.

Deposit

We will book orders up to January 1st without deposit. At that time, a deposit must be paid according to the following terms: You may send the full amount with your order; or you may send 25% with your order and 25% more 30 days before shipping date. We will ship C. O. D. for the other 50%. All prices are f.o.b. here.

Breeding Toms

We specialize in toms and can furnish them in any quantity. These toms are available during Sept., Oct., Nov., and Dec. None will be available after December 31st. It pays to order early and allow the toms time for becoming adjusted to their new environment. There are many advantages in ordering your toms from us. First, you introduce new blood into your breeding flock. This is very essential in order to produce strong vigorous poults. Second, these toms will transmit their broad breasted qualities to their offspring. Next, these toms are properly balanced so as to produce highly fertile eggs. Also these toms have had plenty of clean open range, green feed, and a properly balanced ration which with their fine breeding make them the best money can buy.

We usually have a few thousand breeding hens in the fall of the year. These hens as well as the toms offer an excellent opportunity for Hatcherymen and Egg Producers to improve their stock. Write for prices.

Hatching Eggs

Pure Wagon Wheel Eggs 45c each. Half Wagon Wheel Eggs 37½c each. No less than a case (200) shipped. Prices f. o. b. Hatchery. Guarantee 75% fertility at 12-day incubation period. For replacement or credit, return infertile eggs by prepaid express.

Fill in and return the self addressed envelope order form, with your check or money order. We pay postage. Remember quality birds bring you more profit.

THOMAS TURKEY RANCH
AND HATCHERY
Established 1918

Phone 2802 Clover, S. C.

One of our wagon wheel breedin...

★

Thomas Turkey F...
and Hatchery

Established 1918

Phone 2802 Clover...

These pamphlets are from Thomas Turkey Farm, which operated in Clover for many years.

perience + _Quality_ =
PROFIT FOR YOU

Turkey Ranch & Hatchery had its beginning
...hen a nine year old boy, the present Owner
...ger invested a small amount of money in tur-
With many ups and downs which have al-
...profitable in experience gained, Thomas
...anch & Hatchery has steadily grown; has
...he Industry in this Section; is now one of the
...nches and Hatcheries in the Southeast; and
...as fine Poults as can be purchased anywhere
...s. Poults are our Specialty, but we also have
...Stock and Hatching Eggs for sale.

...homas, the Owner and Manager of Thomas
...anch & Hatchery is, without a doubt, one of
...Turkey Men, in point of Continuous Experi-
...he United States. He has seen the Turkey
...grow from 4,000,000 in 1918 to more than
...in 1945. He is proud to have had a part in
...endous growth. He has really pioneered in
...ng the first in the Country to: (1) Hatch and
...ys by artificial means. (2) Use wire floors
... houses. (3) Advocate clean range away
... Poultry. (4) Advocate specially balanced
...ion. (5) Use artificial lighting for early
... Breed especially to improve market quali-

...rd to improvement in market qualities, we
...up a special breeding program. No effort,
...oney is spared in our efforts to produce the
...lts that money can buy. We are offering
...on Wheel Poults this season. Our Original
...this strain came direct from Judge H. P.
...agon Wheel Ranch. From time to time since
...r original stock, we have purchased eggs

from Mr. Griffin's Pedigreed Pens in order to keep our
stock up to the very highest possible standard of ex-
cellence. During 1945, we turned down orders for many
thousands of these Poults at $1.00 each. In 1946, we are
offering them at 90c. This poult grows out into a well-
balanced, compact bird with short legs and a wonderful
broad breast. This turkey can be marketed at 5 months
of age with well-developed breast. Hens at this age
weigh about 12 lbs. and toms about 20 lbs. They can
also be carried economically and profitably to the age
of 7 to 7½ months with weights of about 20 lbs. for
hens and 30 to 35 lbs. for toms.

We also offer a half Wagon Wheel Poult at 75c. This
turkey is very popular with many of our breeders and
growers. It does not grow out quite as heavy as the
Pure Wagon Wheel, but it develops into a nice medium-
sized bird at about 6½ months.

We have been working for years on the development
of our own particular strain of turkey which we expect
to offer for sale in 1947. This new Thomas Strain
Turkey is the result of years of careful, scientific
breeding. It is a monumental development. After ex-
perimenting with dozens of strains of turkeys—none of
which he considered ideal—Mr. Thomas has developed
what he considers the Commercial Growers', the Breed-
ers', and the Hatcheryman's Dream Bird.

Location

Our Home Ranch consists of 215 acres of fine farm-
ing land in the rolling Piedmont Section of South Caro-
lina. The climate is wonderful here. It never gets
severely hot or cold. We usually have green grazing
the year around.

A flock of young turkeys growing on open range.

Dressed tom—30 pounds— Dressed hen—16
5½ months. 5½ month...

Our Ranch is situated 4 miles out of Clover, S.
Highway 55. We are 30 miles Southeast of Cha...
N. C. and 12 miles from Gastonia, N. C.

Our Breeding Stock

Our breeding hens are hatched at the proper ti...
that we are prepared to use the eggs when the
reach maturity and are ready to produce their
eggs. Many turkey breeders do not understan...
procedure and let their hens lay out several clutch
eggs in a straggly inefficient manner before the
ready to start hatching. The first, second, and
clutch eggs produce the strongest poults. We hav...
hens coming into production every few months
place the hens which have already laid several clu...
of eggs. In this way we keep our poults stron...
vigorous throughout the season.

All our Breeders are selected and banded unde...
National Poultry Improvement Plan by Comp...
State Selecting Agents. Only large, vigorous,...
developed birds without disqualifications are retail
breeders.

In order to keep our birds under the healthiest, ...
est possible conditions we have divided them into
of from 200 to 1000 each which are taken care of
number of entirely separate farms. We have app...
mately 10,000 hens in our Breeding Flocks. All of
are fed a scientifically balanced breeder ration in
to produce good hatching eggs that contain the p...
nourishment for the embryo. It is not just tha...
embryo is fed—that is a normal and necessary pr...
—but how well it is fed that counts.

Small group of breeders.

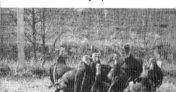

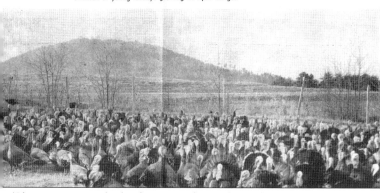

(Photo courtesy of Lib Thomas and Jonathan Thomas.)

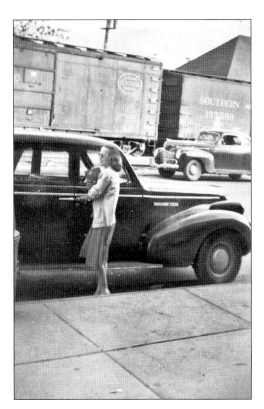

Grace Campbell Smith shops in downtown Clover, c. 1940. This photograph was taken outside Clover Drug Store. The roof of the train depot can be seen behind the train. (Photo courtesy of Margaret and Linden Smith.)

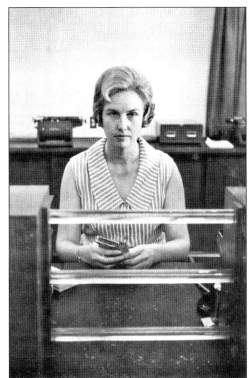

Sara L. Jackson counts money at Bank of Clover, c. 1950. Jackson started her career at the bank in the bookkeeping department. (Photo courtesy of Sara L. Jackson.)

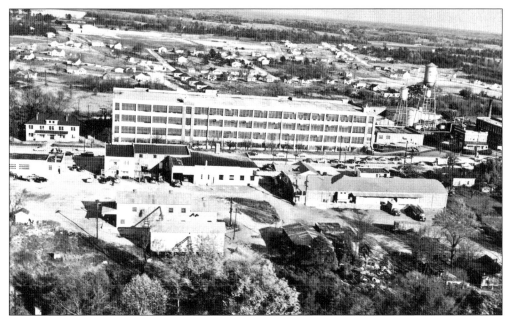

This is an aerial view of Clover from the 1950s. The building in the middle of the photograph is the American Thread Company. Around 1942, American Thread bought the Hawthorn and Hampshire Mills, which had been established in Clover in 1916 and 1923 respectively. (Photo courtesy of Adelle Edmunds.)

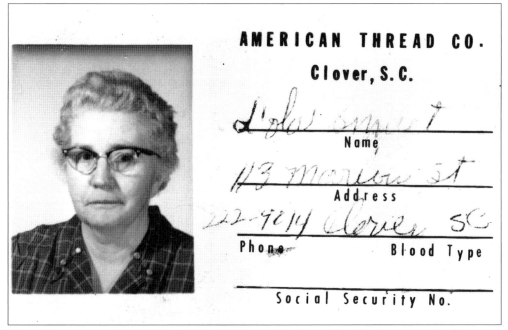

Since Clover was officially founded in 1876, textiles have played a large part in the town. Pictured here is an identification card for Lola Smart, who worked at American Thread Co. In the early 1890s, Capt. William Beatty Smith began working on bringing a textile mill to Clover and eventually collected $30,000 to erect the Clover Cotton Manufacturing Co. (Photo courtesy of Margie Smart.)

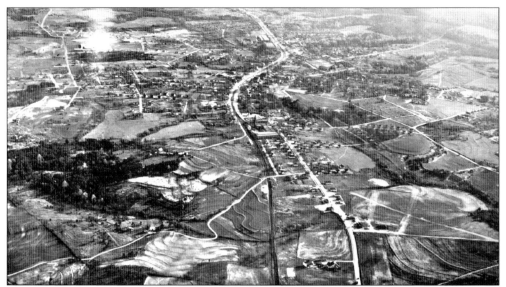

U.S. Highway 321 snakes southward in this aerial view of 1950s Clover. Located in York County, Clover is 30 miles southwest of Charlotte, North Carolina. The small town life and strong community still appeal to Clover residents today. (Photo courtesy of Adelle Edmunds.)

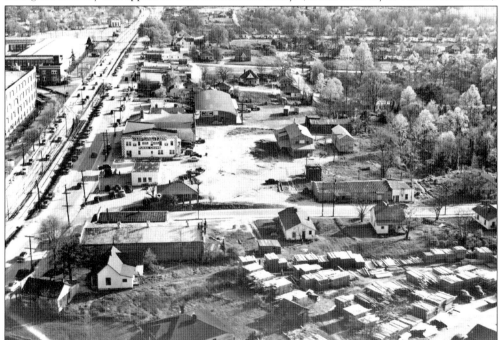

Even the youngest Clover residents can pick out some of the landmarks from this 1950 aerial view. Traffic makes its way down Main Street, which is also U.S. Highway 321, and the corner of the American Thread Company on the left edge of the photograph is recognizable by its many windows. Directly across from American Thread Company on Main Street is the J.S. Edmunds turkey processing plant. Falls Brother Lumber Yard is in the lower right corner of the photo. Also on Smith Street is the former Clover Ice plant, operated by Conan and Claude Pursley. (Photo courtesy of Adelle Edmunds.)

Joe Lawson Jackson, son of Fred Hope Jackson and Emma Frances Ford Jackson, was an active businessman in Clover. He was a C.P.A. and a partner at Ernst and Young. He served as C.P.A. president and mid-Atlantic state president. His wife, Margaret Jackson, taught special education in the Clover School District. Joe Jackson was also president of the South Carolina Checker Association and on one occasion played three simultaneous games of checkers with three different opponents. He won two of the games. (Photo courtesy of Margaret Jackson Woods.)

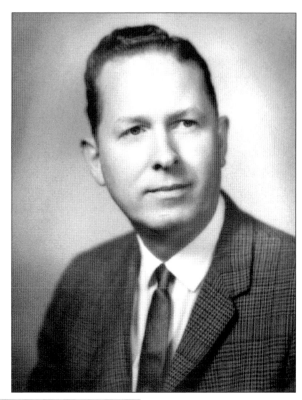

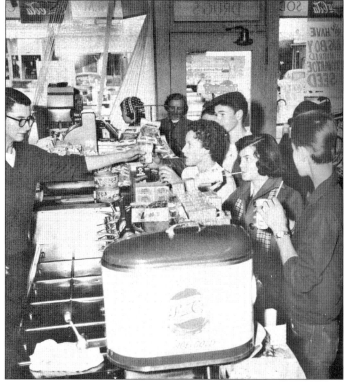

Clover Drug Store was a favorite after-school hangout for Clover teenagers. Here, Webb Curry works the soda fountain and counter as Miss Hazel Sills, a Clover High School math teacher, enters the store. (Photo courtesy of Margaret and Linden Smith.)

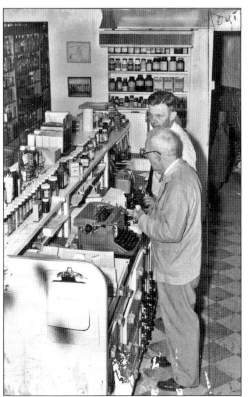

R.L. Wylie and J.M. Wylie, father and son pharmacists, work in Clover Drug Store in 1955. R.L. Wylie moved to Clover in 1907 and purchased the store from Mr. S. Clinton, becoming Clover's first registered pharmacist. He also had a reputation for making delicious ice cream. Piedmont Telephone Co. placed a telephone in the store, but it could call only one number, the railroad station in Gastonia. Dr. Wylie learned men were using the telephone to place orders for quarts or pints of whiskey with the train porter in Gastonia, so he asked that the telephone be removed. When Piedmont Telephone Co. did not respond, R.L. Wylie removed the telephone himself and left it on the street. (Photo courtesy of Jim Wylie.)

R.L. Wylie packs medicine into capsules in 1955. R.L. ran the business until his death in 1964, and son J.M. Wylie kept the store open until the mid-1980s. (Photo courtesy of Jim Wylie.)

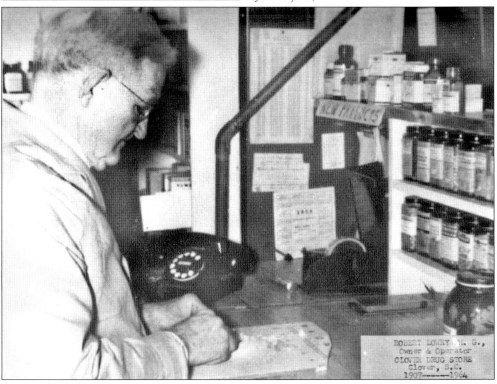

Howard Johnson's Restaurant was a popular gathering place for teenagers in the 1940s and 1950s, especially after football games. Thirty-five–cent sandwiches were the most expensive item on the menu. Cokes cost 6¢. The restaurant closed *c.* 1970. (Photo courtesy of Margaret and Linden Smith.)

HOWARD JOHNSON'S
TOASTED SANDWICHES

SANDWICHES CLOVER, S. C.

Chicken Salad – – – –	.25
Pimento Cheese – – –	.20
Cheeseburgers – – – –	.30
Roast Pork – – – –	.30
Baked Ham – – – –	.30
Bacon, Lettuce & Tomato –	.35
American Cheese – Grilled –	.20
Barbecue – – – –	.25 & .30
Hamburgers – – – –	.25
Ham, Lettuce & Tomato –	.30
Bacon & Egg – – – –	.35
Ham & Egg – – – –	.35
Lettuce & Tomato – – –	.20
Fried Ham – – – –	.30
Ham & Cheese – – – –	.35
Cheese & Egg – – – –	.30
Hot Dog – – – – –	.15

DRINKS

Coca-Cola – – – – –	.06
7-Up – – – – –	.08
Nu-Grape – – – –	.08
Tru-Ade – – – –	.08
Pepsi-Cola – – – –	.08
Pineapple Juice – – – –	.15
Orange Juice – – – –	.10
Grapefruit Juice – – –	.10
Tomato Juice – – – –	.10
Chocolate Milkshakes – – –	.30
Vanilla Milkshakes – – –	.30
Strawberry Milkshakes – –	.30
Sweet Milk – – – – –	.10
Buttermilk – – – –	.10
BEER–Schlitz – – – –	.30
Budweiser – – – –	.30
Red Top Ale – – – –	.30
Miller's High Life – – –	.30
Blue Ribbon – – – –	.30

TOTAL

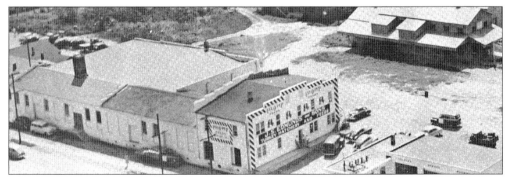

This is a 1953 photograph of the J.S. Edmunds & Sons turkey processing plant. Clover's last cotton gin can be seen in the top right of the photo. (Photo courtesy of Margaret and Linden Smith.)

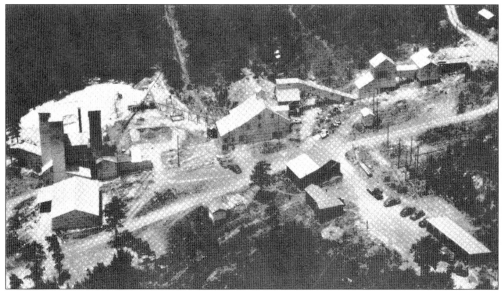

A 1950s aerial photograph shows Commercialores Incorporated's mining operation on Henry's Knob. (Photo courtesy of Margaret and Linden Smith.)

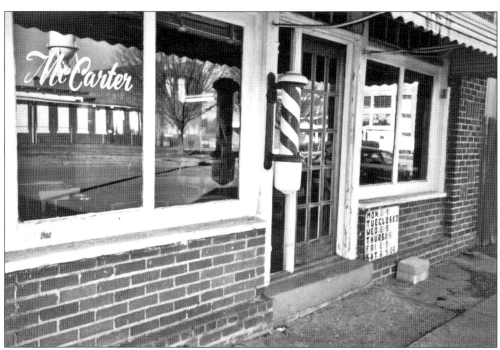

Andy and Duke McCarter, sometimes assisted by brother Joe Lee, have cut hair at McCarter's Barber Shop for decades. For a few dollars, patrons get a haircut and plenty of conversation. The three barber chairs in the shop date back to 1934. The old mill and water tank located across the street from the shop are reflected in the window. (Photo taken by Karan M. Robinson.)

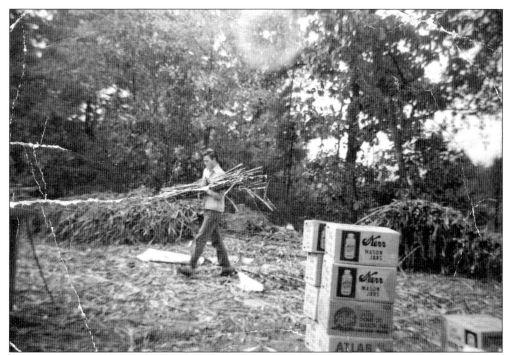

Teenager Columbus "Shorty" Stiles carries sugar cane for molasses-maker Jim Armstrong on Lloyd White Road, c. 1956. (Photo courtesy of Clara Faye and Columbus Stiles.)

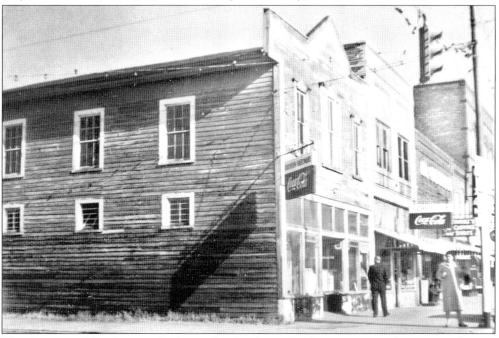

This January 1962 photograph shows the Southern Hardware store at the corner of Kings Mountain and Main Streets. The wooden building no longer exists; in its place today is Clover Centennial Park, developed as part of Clover's downtown revitalization project in the late 1980s. (Photo courtesy of Jim Wylie.)

Earl Ford sits in front of Clover Furniture Store on July 8, 1970. Ford, who owned and operated Clover Furniture Store for over 30 years, was dressed for Clover's Heritage Day activities. Today, the Larne Building is housed in the old furniture store and is the setting for special events, including festivities that take place during visits from residents of Clover's sister city, Larne Borough in County Antrim, Northern Ireland. The building has original hardwood floors and tin ceilings. (Photo courtesy of Brent Clinton.)

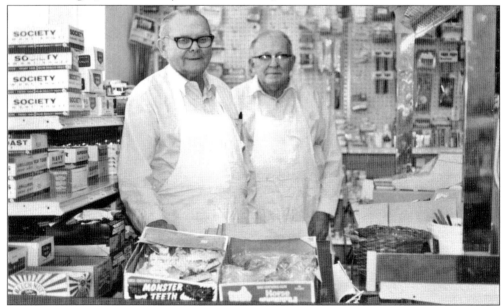

Brothers Campbell and George Jackson work in Jackson Brothers Grocery in the late 1980s. The brothers, who were long-time employees of the store, purchased the business in 1957 from Guy Neil, who owned the store from 1946 to 1957. Prior to that, the Jacksons' cousin, E.L. Adams, was owner and operator. Campbell's son Dickie Jackson and his wife Charlotte currently own the store. Today the store offers a lunch menu and is well known for its tasty coleslaw. (Photo courtesy of Dickie Jackson.)

Four

COMMUNITY

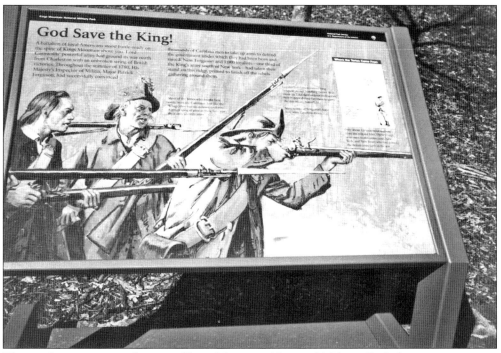

This marker is just one of many at Kings Mountain National Military Park that commemorates the Revolutionary battle of October 7, 1780, in which Patriots defeated Maj. Patrick Ferguson and his men in just under an hour. Visitors to Kings Mountain National Military Park can walk the 1.5-mile battlefield trail that includes Ferguson's cairn and the U.S. monument erected in 1909. Congress established Kings Mountain National Military Park in 1931. Kings Mountain State Park, which offers swimming and picnic areas, is located nearby. (Photo taken by Karan M. Robinson.)

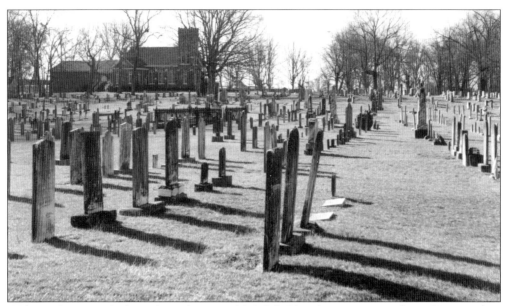

Bethany Associate Reformed Presbyterian (A.R.P.) Church was organized in 1797, nearly a century before the town of Clover was officially founded in the mid-1870s. This photograph of the church cemetery, with the church in the background, features some of the older gravesites. Located just off of Highway 161, the church is minutes away from Kings Mountain National and Military Parks. In 1997, Bethany A.R.P. celebrated its bicentennial. (Photo courtesy of Bethany A.R.P. Church.)

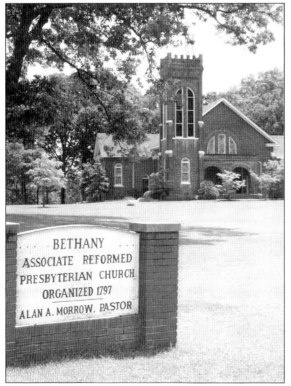

Bethany A.R.P Church is rich in history. Before 1793, Presbyterians in the Kings Mountain area worshiped together; however, in 1793 some members withdrew from the church and applied to the Synod of the Carolinas for a preacher. A Scotch-Irish immigrant, the Reverend William Dickson, was named pastor; two years later, church members peacefully separated. One group went to Gaston County, while the other members formed Bethany A.R.P. The current building was constructed in 1914; prior to that, members worshiped in a log frame church. Pastor Alan A. Morrow has served as pastor since 1992. (Photo courtesy of Bethany A.R.P. Church.)

This $500 South Carolina War Bond was purchased in February 1861 by Myles Smith to benefit the Confederacy's war preparations. Myles was postmaster of New Centre, which later became Clover, from 1851 to 1866. Myles's sons William Beatty, John Josiah, and Robert Patrick all served in the Confederate Army. (Photo courtesy of Margaret and Linden Smith.)

Capt. Beatty Smith signed this Confederate Civil War requisition for two jackets, two pairs of pants, five pairs of drawers, six pairs of shoes, and four blankets. (Photo courtesy of Margaret and Linden Smith.)

This photograph is of Green Pond United Methodist Church, which no longer stands. When the church was organized in 1879, it got its name from a nearby pond that had a greenish tint to it. There have been many changes to the church since its founding. When Highway 55 was routed through church property in 1936, the church was separated from the cemetery. In 1954, members considered adding brick veneer to the church building, but the congregation, led by Rev. George Thomas, decided instead to build a new church. (Photo courtesy of Green Pond United Methodist Church.)

Clover Presbyterian Church was the first house of worship in Clover. W.T. Beamguard built the church in 1881, and in 1908, H.J. Mills became the first full-time minister. A brick building with a central rounded entrance topped by a dome replaced this wooden structure in the 1920s. (Photo courtesy of Ed Stewart.)

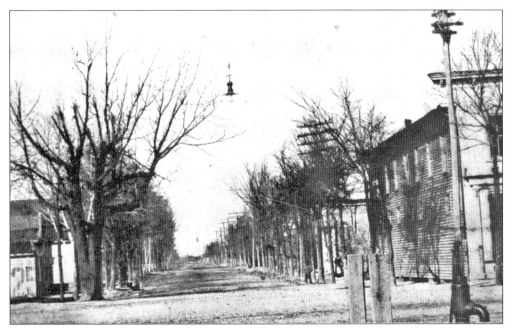

This scene shows Kings Mountain Street around 1908. Even though Clover was not officially founded until 1876, families lived in the area decades before Clover was chartered. By 1882, the town had a few stores, a post office, a church, and a population of about 70. (Photo courtesy of Ed Stewart.)

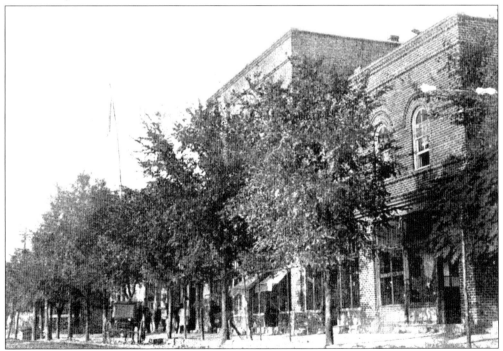

This postcard shows a Main Street scene, c. 1908. Someone named Emily mailed this card to Miss Madeline Faires in 1908. (Postcard courtesy of York County Culture and Heritage Commission.)

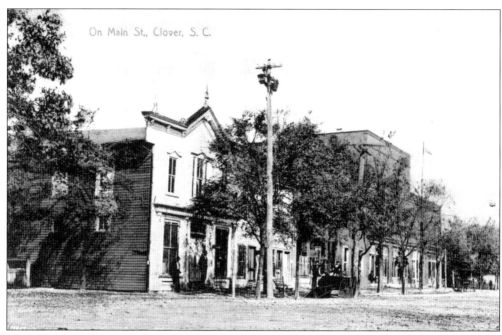

Clover's unpaved Main Street is depicted on the front of this postcard, c. 1909. (Postcard courtesy of York County Culture and Heritage Commission.)

This is the message on the back of the postcard of Clover's Main Street. Neel Sifford mailed the card to Miss Mamie Smith in Clover in 1909. The brief message reads, "Mamie school is out today. The entertainment will be tonight." The card was postmarked May 13, 1909, at 9 a.m. The cost to mail the postcard was a penny. (Postcard courtesy of York County Culture and Heritage Commission.)

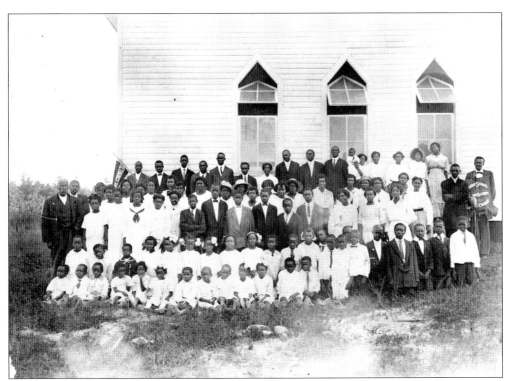

This photograph of Green Pond United Methodist Church Sunday school members was taken in 1916. Founded in 1870, this church was the beginning of the Christian movement for Clover's African Americans and was built on two acres known as Beaver Dam Creek. The first wooden building was destroyed by a 1912 cyclone, but by 1913 the church had been rebuilt. In 1965 a new brick church was built. The church is on Bethel Street in Clover. Green Pond is part of three churches making up the Clover charge. The other churches are Mt. Harmony, organized in 1890, and Clover Chapel, organized in 1913. (Photo courtesy of Green Pond United Methodist Church.)

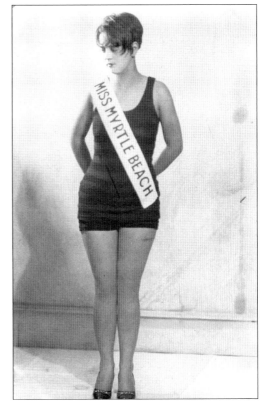

During a visit to Myrtle Beach in June 1928, Lavinia Campbell Smith, the 16-year-old daughter of Dr. and Mrs. I.J. Campbell, was named Miss Myrtle Beach in a beauty contest. The contest was held during a mock session of the South Carolina House of Representatives, of which Dr. Campbell was a member. (Photo courtesy of Margaret and Linden Smith.)

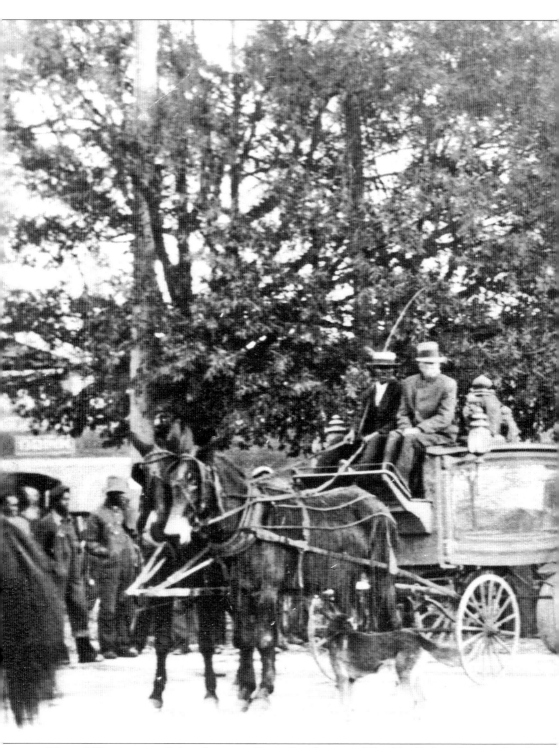

Most of Clover responded enthusiastically to the election of Franklin Delano Roosevelt, who was inaugurated President in March 1933. When they heard that Roosevelt, a Democrat, had beat Republican Wilbur Wilkie, some residents celebrated the end of Republican reign with a

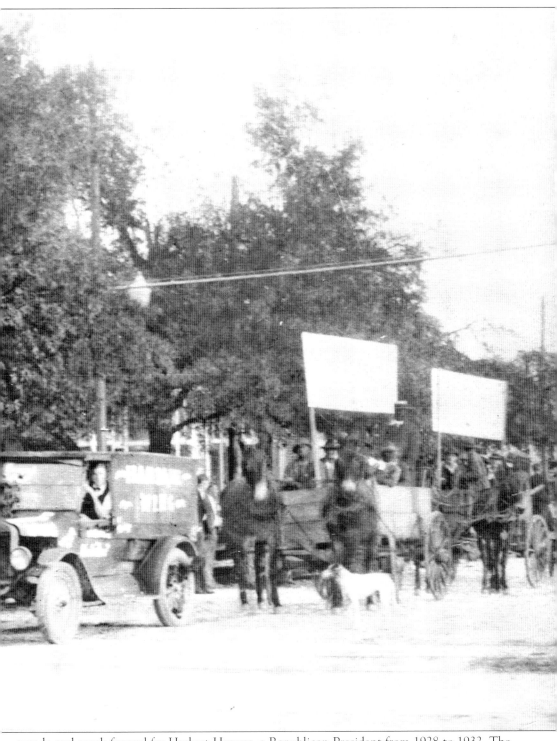

parade and mock funeral for Herbert Hoover, a Republican President from 1928 to 1932. The parade consisted of a horse-drawn hearse and fireworks and ended with the mock funeral for Hoover. (Photo courtesy of Ed Stewart.)

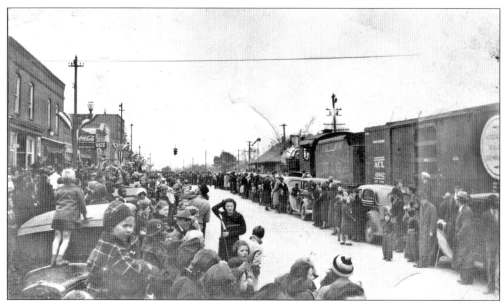

A small child strives for a better look as eager spectators wait for the beginning of an Armistice Day parade in the 1930s. The Armistice was signed on November 11, 1918, and the parade was held to honor the bravery of the men who fought in World War I. (Photo courtesy of Ed Stewart.)

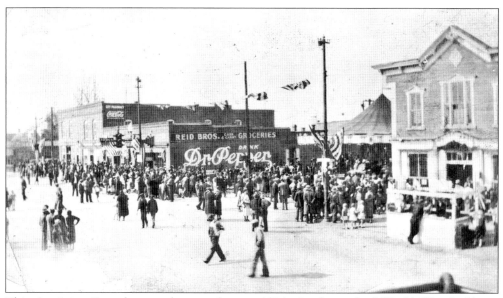

This Armistice Day photograph was taken in 1934. At the end of World War I, Clover residents rang bells, whistles, and sirens. They celebrated with an Armistice Day parade for many years. (Photo courtesy of Ed Stewart.)

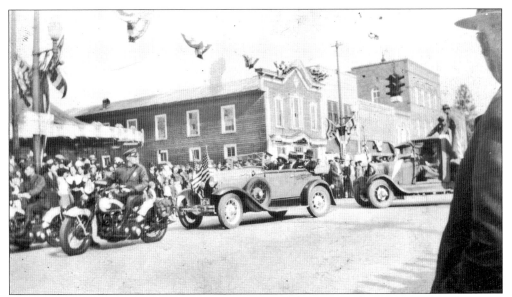

In this 1934 Armistice Day parade, police officers led the way on their motorcycles. Armistice Day was important to the residents of Clover because it marked the ending of World War I. (Photo courtesy of Ed Stewart.)

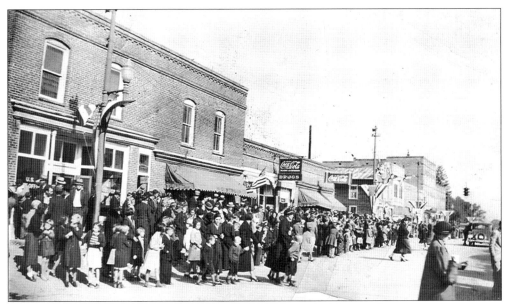

This is the 1936 Armistice Day parade. (Photo courtesy of Ed Stewart.)

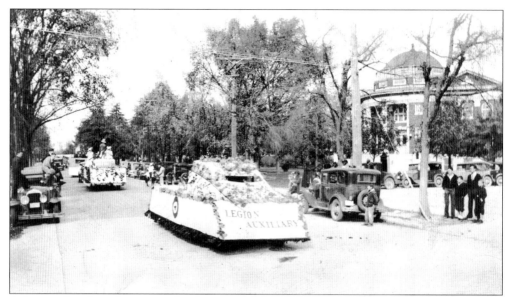

A Legion Auxiliary float passes by the Clover Presbyterian Church during the 1936 Armistice Day Parade. (Courtesy of Margaret and Linden Smith.)

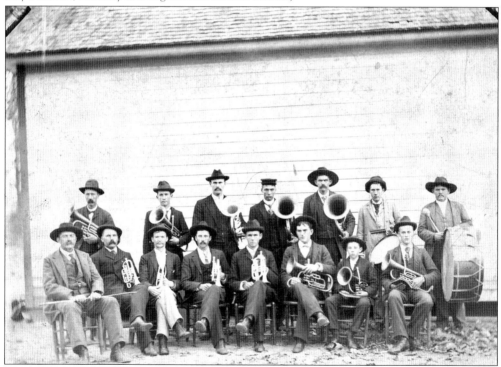

Everyone needs leisure time to pursue outside interests, and these Bethel area men were no exception. This photograph was taken outside the Old Band House, which would later become the A.F. (Mrs. Ruth) Hilderbrand home. They are, from left to right, (seated) L.K. Armstrong, Bob A. Barnett, Tom Kendrick, Jim Campbell, C.T. Brandon, J.B. Ford, John Campbell, S.S. Glenn; (standing) T. Ed Brandon, Campbell Barnett, Dr. Henry Glenn, Wade Hampton Stowe, J. Lee Brandon, J. Meek Barnett, and Newt Brandon. (Photo courtesy of Jim Wylie.)

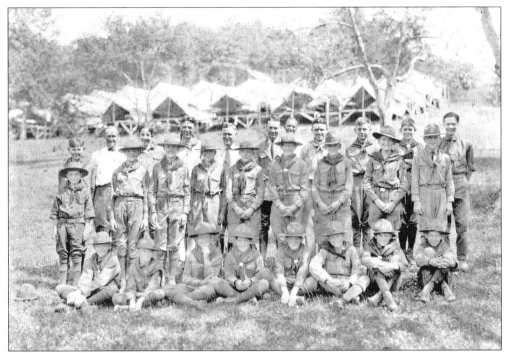

These Clover Boy Scouts spent a week camping in the mountains of North Carolina. (Photo courtesy of Margaret and Linden Smith.)

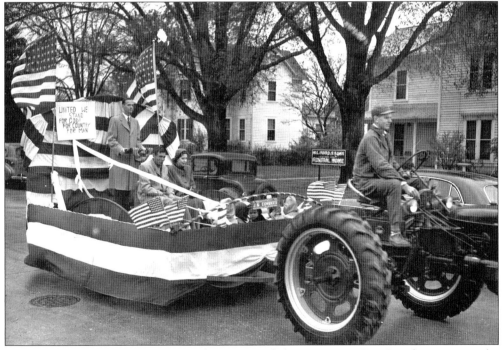

Freelance photographer Lindsay McElwee snapped this Armistice Day Parade picture in the mid-1940s as this float passed M.L. Ford & Sons Funeral Home on North Main Street. (Photo courtesy of Adelle Edmunds.)

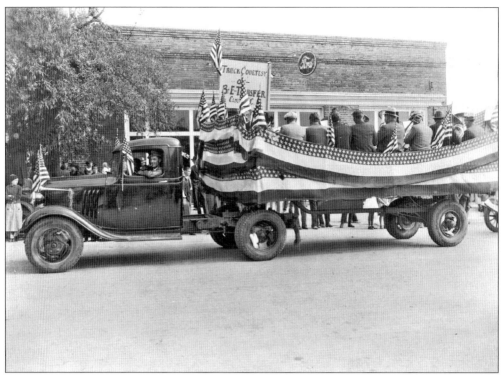

This was another Armistice Day Parade in the 1940s. (Photo courtesy of Adelle Edmunds.)

This view of Clover is from the Ferris wheel during the 1948 Armistice Day Parade festivities. (Photo courtesy of Margaret and Linden Smith.)

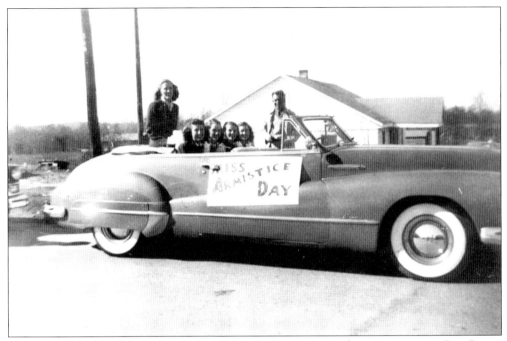

It wasn't a parade without Miss Armistice Day. In this 1948 parade, Miss Armistice Day Queen Evelyn Gettys rode with her attendants. They are Betty Murphy, Kitty Gettys, Jo Ann Thomas, Barbara Ford, and driver Joe McCall.

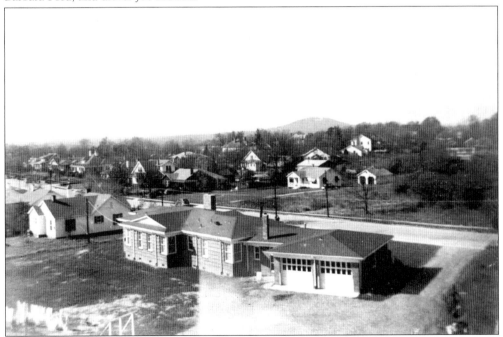

This bird's-eye view from a ride on the Ferris wheel during the 1948 Armistice Day festivities reveals a pristine Henry's Knob rising from the trees. Later, Henry's Knob, located a few miles from the city limits, would be mined for kyanite and pyrite. In the foreground is a home built by the Kirsh family on Pressly Street.

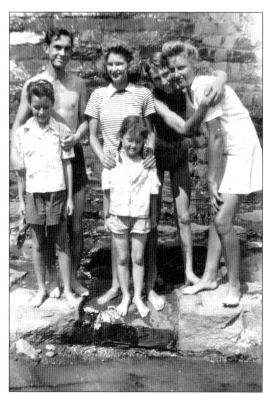

This group cools off at the Kings Mountain State Park dam in this undated photo. Kings Mountain State Park offers swimming at Lake Crawford, camping, fishing, putt-putt, and picnic areas. (Photo courtesy of Sara L. Jackson.)

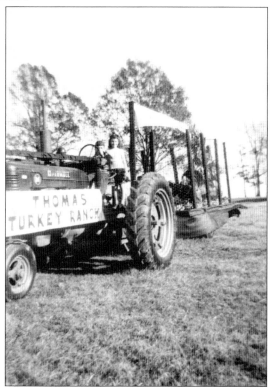

T. Thomas and Betsy Johnson stand proudly on the winning float of the 1949 Armistice Day parade. (Photo courtesy of Jonathan Thomas.)

The Clover Woman's Club was organized in 1950. Some of the charter members and past presidents of the club are, from left to right, (seated) Punch Frances Smith, Bethia Reid, Beth Hinshaw, Marge Jackson; (standing) Willie Westmoreland, Judy Curry, Carolyn Knox, Mickey Wylie, Mary Lou Sifford, and Pinkie Wingare. (Photo courtesy of Margaret Jackson Woods.)

This is the front of a Clover Woman's Club booklet that explained the by-laws and offered other information to members. (Photo courtesy of Margaret Jackson Woods.)

Ruby Craig

The Clover Woman's Club

WHAT NEXT AMERICA?

Clover, South Carolina
1976 - 1977

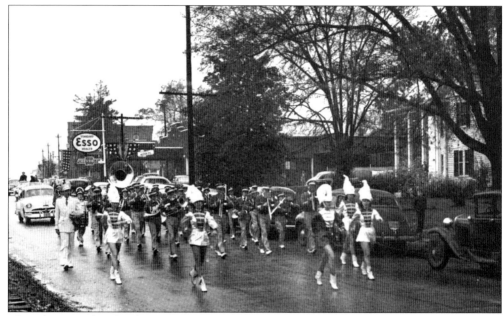

The Clover High School band marches up North Main Street in the 1952 Armistice parade. At that time, the railroad tracks split the downtown area into two parallel streets, with traffic running in both directions on each street. In the 1960s, the town changed them to one-way streets, and in the 1980s, the railroad tracks were removed and replaced with medians of Bradford pear trees. (Courtesy of Margaret and Linden Smith.)

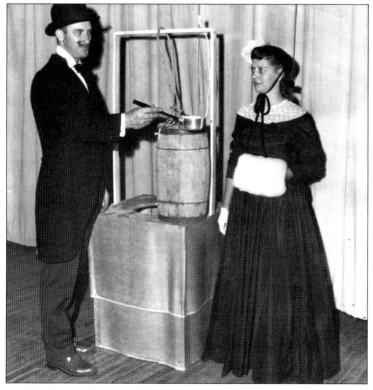

John McCarter and Mrs. Edward H. (Lavinia) Smith were voted Best Costumes at the Armistice Day "Gay Nineties' Revue," c. 1952–1953. (Photo courtesy of Margaret and Linden Smith.)

In 1953, sophomore Grady Monday, a Clover band member, won the State Boys' Contest for baton twirling. He later participated in the 1954 National Contest in Philadelphia. (Photo courtesy of Margaret and Linden Smith.)

GRADY MONDAY

1953 Winner State Boys' Contest

1954 Participant National Contest in Philadelphia

Employees

of

Rebecca "Becky" Louise Smith of Clover was crowned Miss South Carolina 1968. (Courtesy of Margaret and Linden Smith.)

117

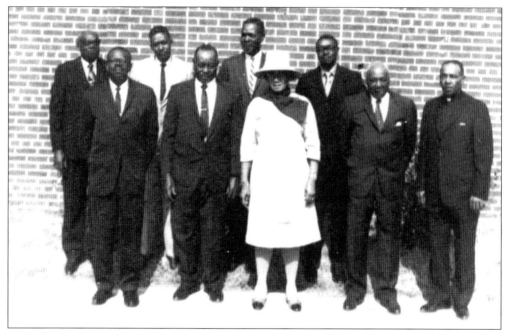

In 1970, Green Pond United Methodist Church celebrated its centennial. At that time, the trustees were as follows, from left to right: (front row) W.C. Wright, L. Watson, Mrs. M.L. Currence, J.I. Jackson, Rev. E.W. Cole; (back row) W.H. Wright, E. Pettus, B.J. Pasley, and S.J. Jackson. (Photo courtesy of Green Pond United Methodist Church.)

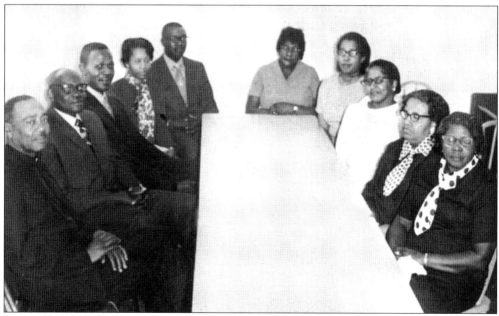

Pictured here are the Council on Ministries members in 1970. The Council was responsible for initiating, developing, and coordinating proposals for the church's mission strategy. The council is, from left to right, Rev. E.W. Cole, W.H. Wright, B.J. Pasley, Mrs. M.R. Jackson, S.J. Jackson, Mrs. V.C. Goodman, Mrs. M.M. Pasley, Mrs. E. Wright, Mrs. E. Jackson, and Mrs. A. Stewart. (Photo courtesy of Green Pond United Methodist Church.)

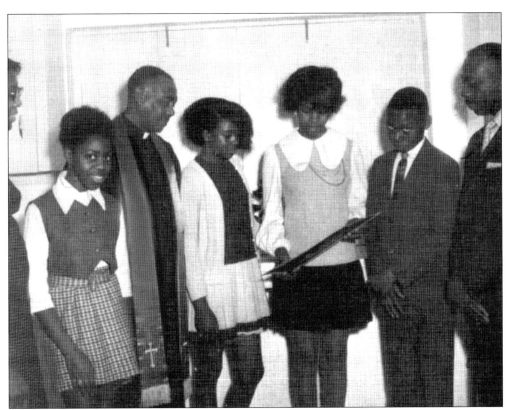

These young church members made up the junior high class at Green Pond United Methodist Church, c. 1970. (Photo courtesy of Green Pond United Methodist Church.)

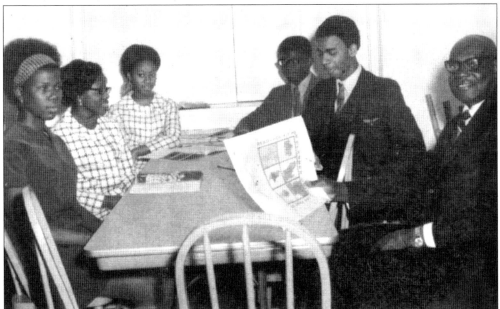

The senior high class members of Green Pond United Methodist Church in 1970 appear to be deep in debate. (Photo courtesy of Green Pond United Methodist Church.)

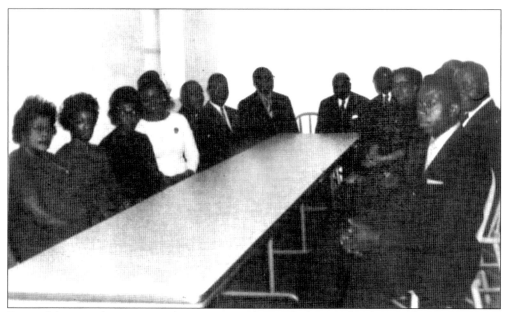

Pictured here is the centennial committee who worked to make the 100th celebration of Green Pond United Methodist Church possible. (Photo courtesy of Green Pond United Methodist Church.)

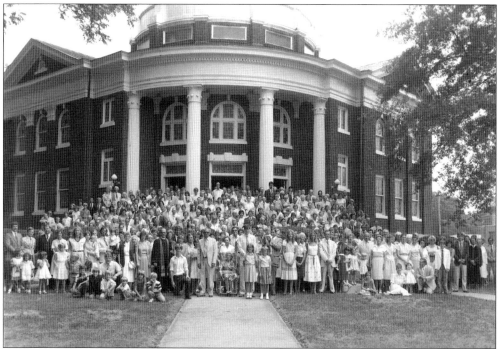

This occasion marked the centennial celebration for Clover Presbyterian Church in 1981, in which church members buried a time capsule. The first Clover Presbyterian Church was a wooden structure but was replaced with this brick building in the early 1920s. The church has neoclassical styling and a semicircular façade with a dome entrance. (Photo courtesy of Margaret Jackson Woods.)

Clover businessman Dickie Jackson, who was president of the Jaycees in 1980, is seen here with former South Carolina governor Dick Riley. (Photo courtesy of Dickie Jackson.)

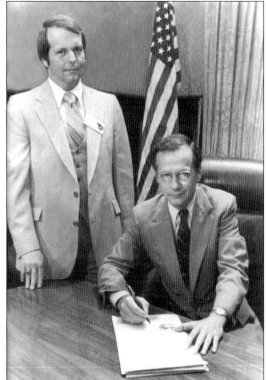

This is a view of Bethel Street facing west in the 1980s. The car in the middle of the photograph sits at Clover's main intersection between U.S. Highway 321 and Highway 55. Travelers headed North on 321 can reach the North Carolina mountains in a matter of hours, while driving south on 321 leads to Columbia, South Carolina, the state capital. (Photo courtesy of Clara Faye Stiles.)

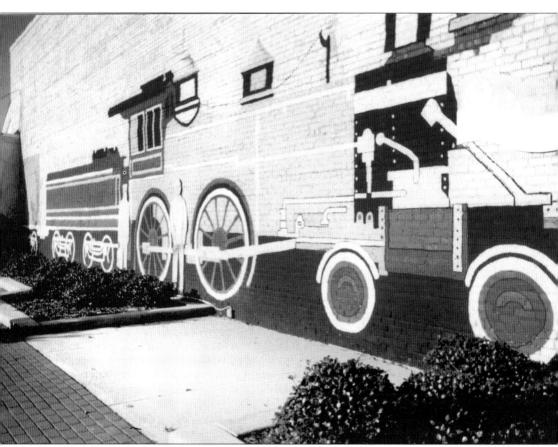

This eye-catching mural adorns the side of Clover's Larne Building and pays homage to the impact the railroad had on the founding of Clover. The town was founded in the mid-1870s as a watering station for steam engines on the Chester and Lenoir Narrow-Gauge Railroad. The railroad tracks, which divided Clover's four-lane Main Street for generations, were removed in the 1980s. The land for Clover Centennial Park, located beside the Larne Building, was donated to the town by Jenny Akers Scheffler. (Photo taken by Karan M. Robinson.)

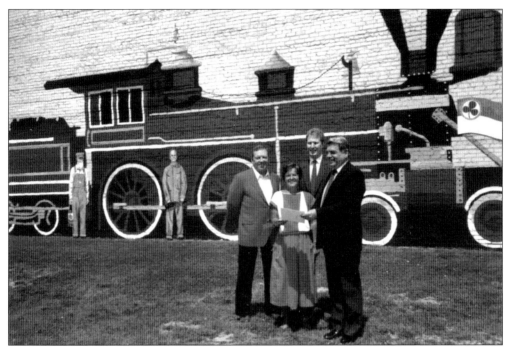

Jenny Akers Scheffler of Massachusetts donated a 27-foot-by-90-foot lot to the town of Clover in April 1987 for use as a park. Scheffler was born and raised on Kings Mountain Street and donated the land as a memorial to her family. Standing in front of a mural on the side of what was then Clover Furniture Co. are, from left to right, Bill Hershman, Jenny Akers Scheffler, Franklin Pendleton, and Hugh Robinson. (Photo courtesy of Margaret and Linden Smith.)

Charter members of the Clover Woman's Club, an organization begun in 1950, ride in a 1987 Cloverfest parade, with Margaret Jackson Woods at the wheel while Louise Smith and Peggy Robinson wave to the crowd. (Photo courtesy of Margaret and Linden Smith.)

In May 1995, spectators lined Kings Mountain Street as the Tour DuPont whizzed through Clover. Most were hoping for at least a fleeting glimpse of world champion cyclist Lance Armstrong, who went on to victory in this event. (Courtesy of Margaret and Linden Smith.)

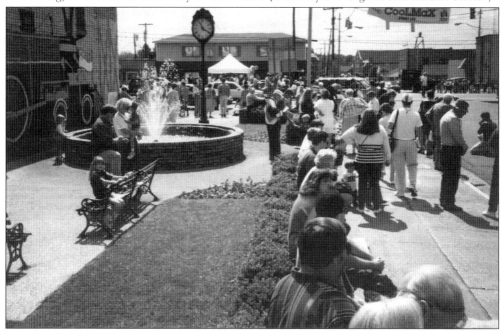

Townspeople mill about in Clover Centennial Park, awaiting the 1995 Tour DuPont cyclists. The park on the square was developed on land that Clover native Jenny Akers Scheffler donated to the town in 1987. (Courtesy of Margaret and Linden Smith.)

Clover police officer Mark Gooch poses with two clowns at Clover's National Night Out, a police-sponsored event to introduce people to their neighbors and to promote community crime fighting, in the mid-1990s. (Photo courtesy of Clara Faye and Columbus Stiles.)

Here is some more clowning around at Clover's National Night Out. (Photo courtesy of Clara Faye and Columbus Stiles.)

Margaret and Linden Smith were the host family for Clover's second annual Feis Chlobhair: A Clover Kinntra Gatherin' festival in 1998. The "gathering in the country" event pays tribute to Clover's Scotch-Irish heritage. In 1997, Clover established a sister city relationship with Larne, County Antrim, Northern Ireland. Many people in England, Scotland, Wales, and Northern Ireland share the Smith surname. The Smiths' ancestors had a tremendous impact on Clover's growth. (Courtesy of Feis Chlobhair from the Feis Chlobhair program.)

Bagpipers from the Palmetto Pipe and Drum Band put on a show at Clover's Feis Chlobhair Festival in June 2001. Feis Chlobhair, Gaelic for "country gathering," honors the Scotch-Irish heritage of many Clover area residents. Other musical acts at the festival over the past seven years have included Scottish vocalist Bobby Murray, Sunday Session, and Neil Anderson. There is also Irish dancing by the Rince na hEireann dancers of Charlotte, who perform traditional Irish dances emphasizing quick footwork. (Photo courtesy of Ed Stewart.)

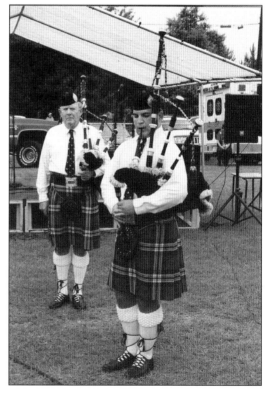

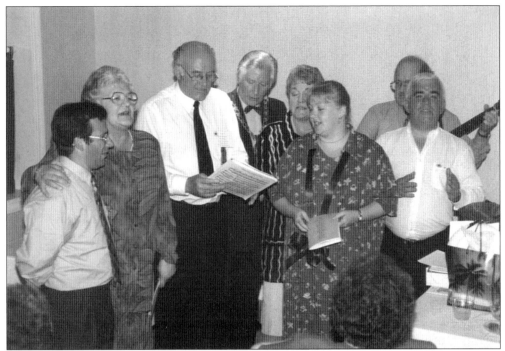

Larne and Clover residents mingle during a visit. Dr. David Hume, on the left, is a frequent visitor to Clover, especially during the Feis Chlobhair festival. (Photo courtesy of Ed Stewart.)

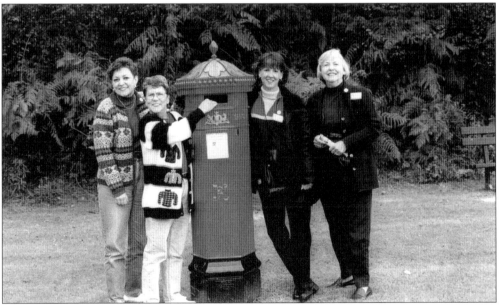

During a trip to Larne, Northern Ireland, in 1998, Margaret Rhyne, Ann Harvey, Neel Cyphers, and Bebe Stine pose beside a mailbox. Since Clover formed a sister city relationship with Larne Borough in County Antrim, Northern Ireland, in 1997, several groups from Clover have made trips to the Emerald Isle to visit. Some Clover residents have also hosted Irish visitors in their homes, usually during the Feis Chlobhair: A Clover Kinntra Gatherin' festival that takes place each June. (Photo courtesy of Ann Harvey.)

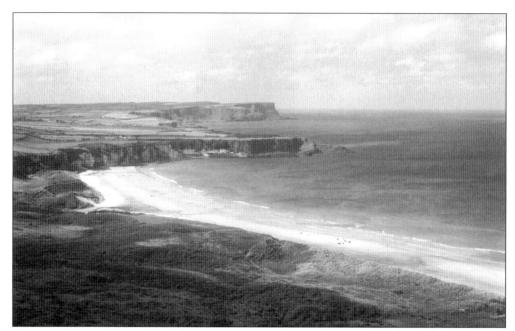

Clover residents of Scotch-Irish heritage can trace their roots to Ireland. This photograph was taken off the coast of Ireland in 1998. One of the first settlers in the Clover area was David Jackson, who was born in County Antrim, Northern Ireland, and his wife, Mary Morrison Jackson. After receiving a 903-acre land grant from King George III, the Jacksons sailed for America and settled in an area that is east of the present town of Clover. A number of Clover residents are descendents of David and Mary Jackson. (Photo courtesy of Ann Harvey.)

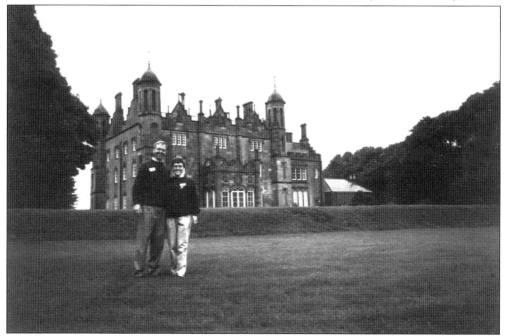

Former mayor Vance Stine and Ann Harvey stand in front of one of Ireland's majestic castles in this 1998 photograph. (Photo courtesy of Ann Harvey.)